Frank Lloyd Wright

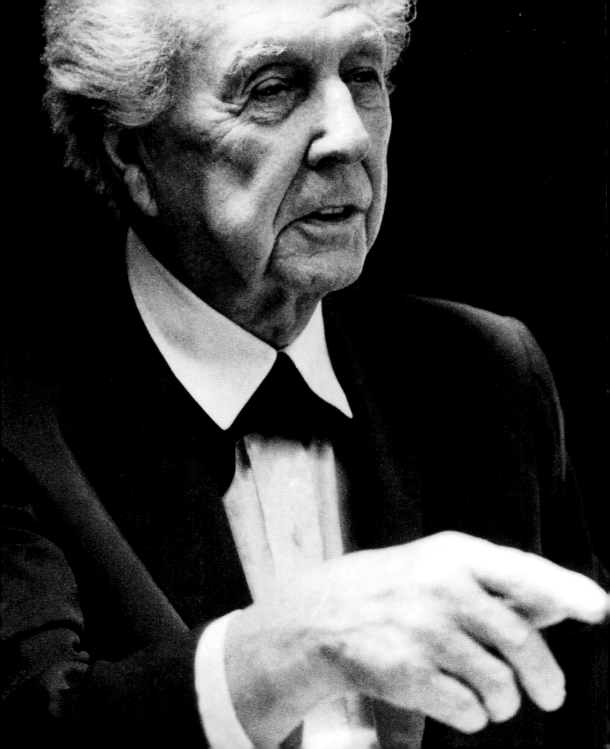

Arnt Cobbers

Frank Lloyd Wright

Life and Work

KÖNEMANN

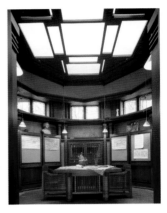

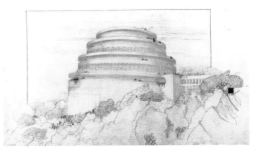

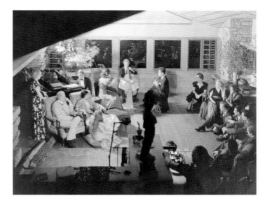

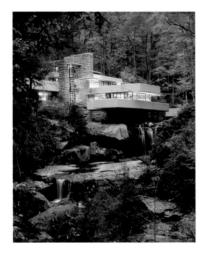

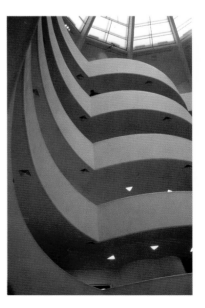

Formative Years 1867–1893

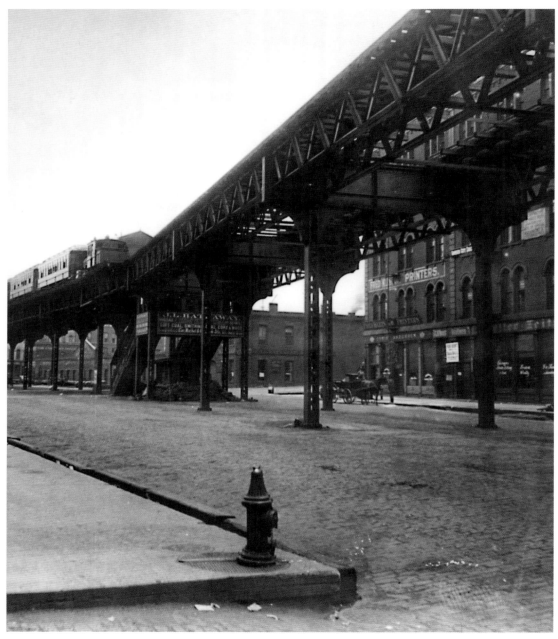

Frank Lloyd Wright was born in Richland Center, Wisconsin on June 8, 1867. His mother wanted him to be an architect: She put up architectural engravings in the whole apartment and gave Frank Lloyd the educational blocks of the German pedagogue Friedrich Froebel to play with. This is how Wright developed a sense of geometry and an interest in architecture in his very early years. After graduation, he spent two semesters studying at the University of Wisconsin in Madison, the state capitol. Among others, he took classes in engineering. He worked for a construction company to earn a bit of money on the side. At the age of 19, Wright was drawn to the big city, and he started working as a draftsman for the practice of the famous Chicago architect Joseph L. Silsbee. One year later, he quit and began to work for Adler & Sullivan, the leading avant-garde practice of the city. Wright was soon involved in all larger projects as a draftsman. On the side, he took up contracts for apartment buildings that Sullivan was generally not interested in. For financial reasons, he finally started building houses also on his own account. When Sullivan found out about this, he dismissed Wright.

Inauguration of the Statue of Liberty

1867 The USA buy Alaska from the Russians.

1873 The Vienna stock-market crash marks the beginning of the Great Depression which strongly limits economic growth until 1895.

1879 Thomas A. Edison invents the electric light bulb.

1883 Brooklyn Bridge is opened to the public (then the longest suspension bridge of the world).

1886 France gives the Statue of Liberty to the USA. The Coca-Cola syrup is invented by a pharmacist in Atlanta.

1893 World Fair of Chicago.

Frank Lloyd Wright around 1895

1867 Frank Lloyd Wright is born June 8 in Richland Center, Wisconsin.

1883 His father William Wright leaves the family.

1885 Wright enrolls at the University of Wisconsin, Madison.

1887 Wright starts working as a draftsman for the practice of the Chicago architect Silsbee.

1888 Wright now works for Adler & Sullivan, one of the most important Chicago architectural practices.

1889 Wright builds his own house in Oak Park, Illinois and marries Catherine Lee Tobin.

1893 Sullivan dismisses Wright.

Opposite:
Chicago at the turn of last century, photo, 1895

Right:
Frank Lloyd Wright (next to the empty chair on the right) with the extended family of Lloyd Jones' in Spring Green, Wisconsin, photo, 1883

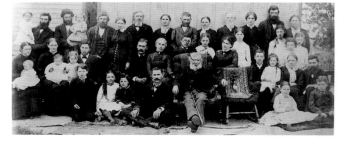

Designs of the German Pedagogue Friedrich Froebel for his educational blocks

Froebel's wooden toy kits were designed to guide the creative play of children and further their abilities for geometric abstraction. They were formative for Wright's concept of architecture.

Itinerant Youth

In his autobiography, Frank Lloyd Wright kept inventing and perpetuating legends about himself. Only in recent years have new documents shed a different light on some facets of his life. Wright always stated his year of birth as 1869. However, today it is known that he was born Frank Lincoln Wright on June 8, 1867. He was the first child of the 47 year old

Wright's parents Anna Lloyd Jones and William Wright, photos, undated

Wright's father had studied medicine and law, but then became a preacher. He gave concerts as a pianist, organist, and singer and was also a composer. Anna took care of the household and the children.

preacher William Wright and the 30 year old Ann Lloyd Jones. Three elder children from his father's first marriage left the family early on, but Wright must have spent at least his early childhood with them. In his autobiography he does not mention them with a single word: Wright only writes about his two sisters, one of them two, the other ten years his junior. His parents could not have been more different from one another. Anna Lloyd Jones was a self-confident and energetic but also moody woman, intelligent but without higher education. She came from a large family, who valued their Welsh heritage highly. Her nine siblings lived in close proximity to her in the hills of Wisconsin near Spring Green, where Frank's grandparents had settled in the 1840s.

Frank's Father William Wright came from Connecticut. He had the reputation of a music enthusiast, a master in the art of living, eloquent, charming, and gifted in many areas. However, he was incapable of deal-

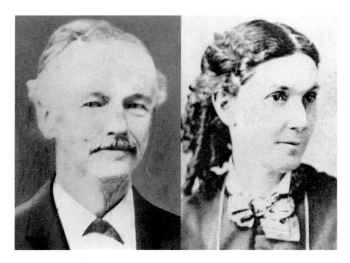

ing with money, a trait that should also mark the life of his son. William Wright would often take on new positions full of enthusiasm, but all of his hopes would quickly be disappointed. This is why the young Wright spent a restless childhood, moving from Wisconsin to Iowa, Rhode Island, Connecticut, and Massachusetts. In 1877, the family returned to Wisconsin for good. From 1879 on, they lived in Madison, the state capitol. Frank had always been a loner, and his performance in all of the four schools that he attended was rather poor. He did not receive a diploma. In 1883, Anna separated from her husband. She probably could not bear his irresponsible life and the deprivations for the family that it entailed. Her brothers took care of her and her children; the father disappeared from Wright's life. He probably never saw him again. After the separation from his father, the influence of his mother's family became stronger, and thus the Welsh orientation of the Lloyd Jones' was passed on to the boy. Frank Lincoln Wright changed his middle-name to Lloyd.

The summer months at an uncle's farm in Wisconsin were the resting point in Frank's youth. Here he did not only develop his love for nature but also his enthusiasm for farm labor on the field, which later should play an important role in the pedagogical concept of his school for architecture, the Taliesin Fellowship.

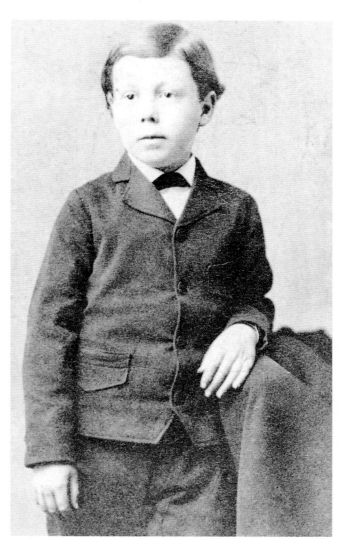

Frank Lloyd Wright at the age of 10, photo, 1877

Wright learned to play the viola and the piano as a child, and liked doing arts and crafts. His mother wanted him to become a great architect, so she put up engravings of English cathedrals everywhere in the apartment and took Frank to many exhibitions. The young Wright was a loner. His only close friend was a boy in Madison, who had lost both legs to Polio. He even shared his book prizes – his sole pride – with him.

Departure for Chicago

In 1885, Wright spent two semesters at the University of Wisconsin in Madison taking classes in English, French, mathematics, and engineering. Additionally, he took on a part-time job with Connover, the owner of a construction company. In the beginning of the year 1887 Wright departed for the big city, Chicago. The 19 year-old applied for a position with the well-known architect Joseph L. Silsbee. Silsbee had just been commissioned to build the new church for the Unitarian congregation by Wright's uncle Jenkin Lloyd Jones, who was the pastor of that church. Wright was

UNITY CHAPEL, HELENA, WIS.

Design for Unity Chapel, Helena, Wisconsin, 1886
Wright's first published design

Streetscene in Chicago, photo, 1905

accepted by Silsbee as a draftsman. Wright came to the city with the best prerequisites: He was very talented, possessed basic technical knowledge and craft skills, was unburdened by academia, and above all very self-confident. His mother had successfully instilled in him the conviction that he was called to greatness. He impressed his coworkers with an inexhaustible energy and an iron will to work. On the other hand, Silsbee's architectural practice proved to be a lucky strike for the young Wright: He got to know an extensive repertoire of forms and details without being pushed into one stylistic direction. Wright received the meager salary of 8 dollars a week. However, when the experienced George W. Maher, who should later become very successful, started at Silsbee's for 18 dollar a week, Wright demanded the same salary. Silsbee declined and Wright left. He was rehired a short time later – for 18 dollars a week. His fight for money

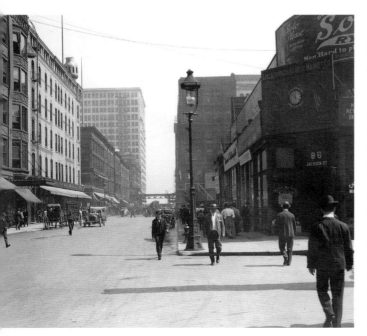

was not without a reason: Wright had left debts in Madison that his mother was now being confronted with. Wright's honor was challenged. He also wanted to support his mother and his then only 10 year-old sister Maginel financially. As soon as 1887, he took them to Chicago to live with him.

Wright also needed the money to be able to pay for his social life, because as an uprising architect he had to "come out." At an afternoon dance at the church of his uncle, Wright collided with a couple. The young lady fell, and Wright also got quite a bruise. When he accompanied the 17 year-old Catherine Lee Tobin home, her parents invited him for the next evening. "Kitty" and Frank were married two years later.

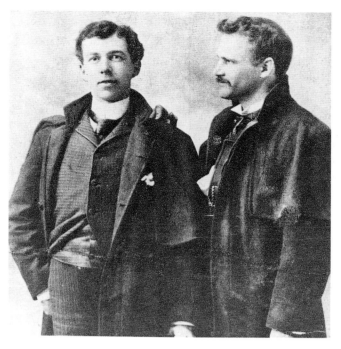

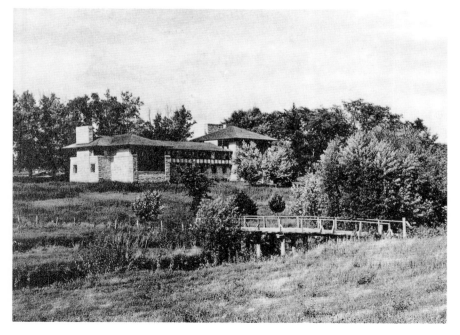

Above:
Frank Lloyd Wright (left) with his friend and colleague Cecil Corwin, photo, 1887

Hillside Home School, Spring Green, Wisconsin, 1902

Wright was able to realize his first own design in the summer of 1887: the Hillside Home School in Spring Green, Wisconsin. It was a boarding school for all age groups that had been founded by two of his aunts a year before. In 1902, Wright replaced the building by a new one.

Years with the "Lieber Meister" (Beloved Master)

Wright quit his job at Silsbee in the end of 1887 and started working for Adler & Sullivan, one of the most progressive architectural practices of the city. The older partner, Dankmar Adler, was the engineer and manager, Louis H. Sullivan, then only in his early 30s, was the artist and theorist in this partnership. Sullivan, whom Wright affectionately gave the German title "Lieber Meister," beloved Master, was the rising star in Chicago's architecture.

Wright was soon involved in the large

Louis H. Sullivan, photo, 1895

In his time, Sullivan was renowned for his high-rise buildings, today he is known for his theoretical writings (see page 14). After breaking up with Adler in 1895 he never caught up again with his former success.

projects of the company: the Auditorium Building, the Wainwright Building in St. Louis, as well as the Transportation Building for the World Fair in Chicago in 1893. The young draftsman was first ridiculed as a farm boy by his colleagues, but he quickly gained their respect. Soon he was chief designing assistant, responsible for 30 other draftsmen. When the practice moved to new rooms two years later, the 21 year-old was placed in an office next door to his "Lieber Meister." In his autobiography, however, Wright does not mention that he had to share the room with a colleague.

In 1889, a loan by Adler & Sullivan enabled Wright to buy a piece of land in the quiet and green sub-

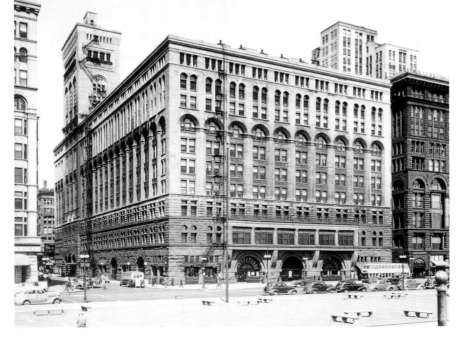

Adler & Sullivan
Auditorium Building, Chicago, Illinois,
1886-1889,
outside view

Between 1886 and 1889, Adler & Sullivan built the largest concert building of the time. The façade resembles the massive neo-Romanesque buildings of the then leading US-architect Henry Hobson Richardson. However, in the inside, Sullivan expressed his delight in elaborate ornamentation. The room decoration consists of complicated intertwining plants, grasses, and leaves.

Charnley House, Chicago, Illinois, 1891, front view

The most important work that Wright designed for Adler & Sullivan is Charnley House, which was completed in 1891 in classy Astor Street in Chicago's Near North Side. The smooth three-story detached house has a totally symmetrical lay-out. It has a small canti-levered roof and screened windows. The façade is horizontally and vertically divided into three parts. Brick walls are placed on a base of ashlar. The orna-mentation of the central bay and of the roof-frieze on this otherwise simple building remind of Sullivan's style, who probably gave the building its final touch. The floor plan of the house, which is only one room deep, is also divided into three parts: the en-trance leads to the large staircase, the living room is located on one side of the staircase, and the dining room on the other. The bedrooms are on the first floor.

urb of Oak Park. Now he could finally marry Catherine, start a family, and build his own house.

In return for the loan, Wright committed himself to stay with his employers for 60 dollars a week for the next five years. According to Adler, this made him the highest-paid draftsman in town.

Adler & Sullivan hardly ever built residential houses because large projects were more profitable. Such projects that Sullivan could not reject without loosing a client were given to his young employee. This is how, from about 1888 on, Wright became responsible for the practice's designs of residences. He even built two for Sullivan himself: one city house in Lake Avenue and a country house in Ocean Springs, Mississippi. When the clients started to turn to him directly, Wright started to work on his own account under the name of his friend Cecil Corwin. This so-called moonlighting was widely spread in Chicago at the time. Wright probably did not consciously want to defraud his boss, but needed to get a grip on his still miserable financial situation. However, when he built three houses in the vicinity of Sullivan's home, the "Lieber Meister" recognized the handwriting of his employee: There was a big quarrel and Wright was dismissed. Wright and Sullivan did not have contact in a long time. Only ten years later did they resume their friendship and stayed close friends until Sullivan's death in 1924.

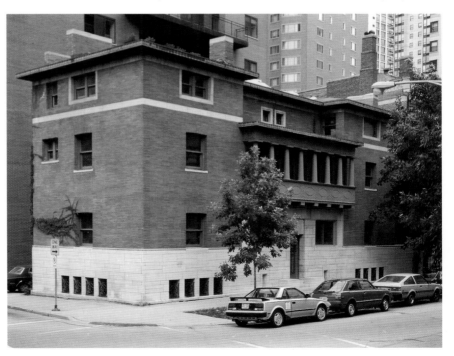

World Fair of 1893: Antagonists and Models

The 1893 World Fair in Chicago was a central turning point not only in the history of architecture but also in the life of Frank Lloyd Wright. It brought him into first contact with Japanese architecture. Apart from Sullivan's considerable influence, this experience was formative for his stylistic development. The World Fair also brought the spread of historicist ideals, an architecture oriented toward the classical European style. They were to mark American architecture for decades to come, and they pushed modern concepts like those of Louis H. Sullivan and Frank Lloyd Wright to the margins. Adler & Sullivan was the only practice of the ten participating architectural companies that refused to go along with the new ideal. Sullivan detested the conspicuous extravagance and rich ornamentation that marked the new eclecticism. He insisted on his own style with the construction of the Transportation Building. Wright went through a short classicist phase at the time, betraying his "Lieber Meister." One example is his draft for the library in Milwaukee, whose geometrical partition of the façade reminds of the German architect Karl Friedrich Schinkel.

Only later did Wright subscribe fully to the ideals of his mentor. In Sullivan, who was eleven years his senior, Wright saw an architect who followed his own path without compromising and who developed his own style without adapting to the current taste. Sullivan spoke out sharply against the historicist façades that were attached to the front of just about any building; a façade should express the function and inner structure of a building. He did not believe that mere representation of the inner structure in the façade would make a building beautiful. Revealing function and inner structure for him simply was the basis out of which the form should develop naturally. This is what he meant by his motto: "Form follows function," which has been thoroughly misunderstood and became the battle-cry of modernity. Sullivan thought of himself as prophet of democracy: He demanded that the American democracy and independence should be reflected in the style of living. A democratic architecture was

Left:
Adler & Sullivan
Transportation Building, Chicago, Illinois, 1893, outside view

Top:
Design for the competition for the public library of Milwaukee, Wisconsin, 1893

needed, with its own, native style to counterbalance the formally strict and vertically oriented architecture in densely populated Europe.

Sullivan and Wright demanded a native American architecture, which should reflect the wide landscape of the prairies, the free space, the horizontals. However, no concrete stylistic influence of Sullivan can be detected in Wright's work.

On the other hand, the influence of Japanese architecture is striking. Wright had probably come into contact with Japanese wood engravings through his first employer Silsbee, but it was only at the World Fair that he ever saw a Japanese temple. Obviously, Wright was influenced by this experience, even though he always denied it. The parallels to his independent works are prominent: the white fillings of the dark wood frames, the extension of the buildings into the surrounding nature, the open interior plan, the emphasis on the horizontal, the generous windowing, and the relatively flat, cantilevered roofs. In later years, Wright did at least admit to an influencing role of Japanese prints: "Japanese prints had intrigued me and taught me much. The elimination of the insignificant, a process of simplification in art in which I was myself already engaged, ... found much collateral evidence in the print. And ever since I discovered the print Japan had appealed to me ... Japanese art and architecture really did have organic character."

Japanese Temple, Chicago, Illinois, erected 1893 for the World Fair, front view

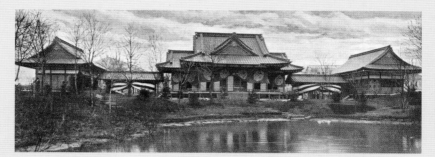

Premises of the World Fair in Chicago, Illinois, photo, 1893

Finding his own Path

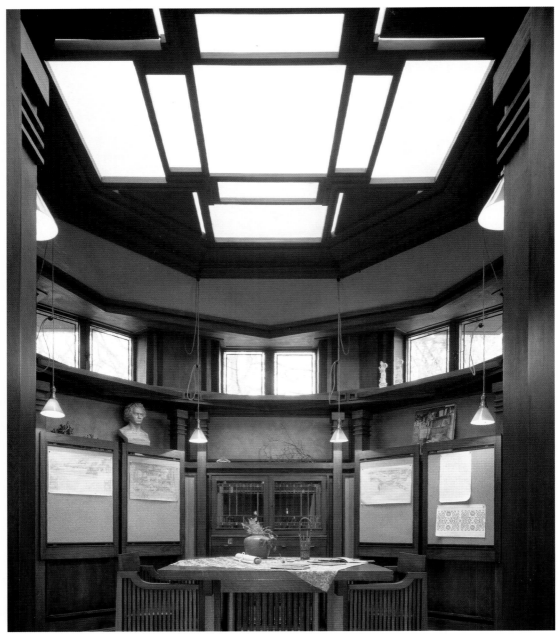

After his dismissal from Adler & Sullivan, Wright started to work free-lance, first in partnership with his friend Cecil Corwin and other young architects, then from his own office. He won the competition for a boathouse. With the strictly symmetrical Winslow House in the Chicago suburb River Forest, he built his most important house before the turn of the century.

The young architect was consistently awarded new commissions, not least because of his marriage to Catherine Lee Tobin whose parents eased his entry into the wealthy circles of Oak Park. Wright erected several residences for the upper middle-class, most of them in the suburbs of Chicago.

Oak Park became the center of his life in no later than 1895, when he built an annex with office rooms for himself and his draftsmen. His designs increasingly displayed some of the central characteristics of the Prairie Style, which Wright would later become famous for.

US-president Theodore Roosevelt

Frank Lloyd Wright in the year 1900

1895 First public performance of films in Paris and Berlin. Alfred Nobel donates the Nobel Prize.

1898 War between the USA and Spain about Cuba. As a consequence, Spain has to hand over the Philippines and Puerto Rico to the USA, Cuba gains independence. Spain looses its role as a colonial power. The USA, on the other hand, become the new world power.

1899 Aspirin is marketed for the first time.

1901 Theodore Roosevelt becomes the 26th president of

1893 Wright opens his first own practice in Chicago.

1893-94 He builds Winslow House, his most important work before the turn of the century, and enlarges his house in Oak Park, adding a playroom.

1895 Wright adds a studio complex to his Oak Park house.

1900 Wright builds Bradley House and Hickox House in Kankakee, Illinois, creating the two prototypes for his later Prairie houses.

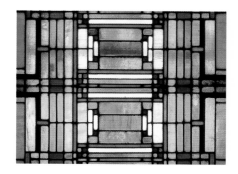

Frank Lloyd Wright's house and studio, Oak Park, Illinois, 1889-1895
Study (opposite) and ornamental skylight in the entrance hall (right)

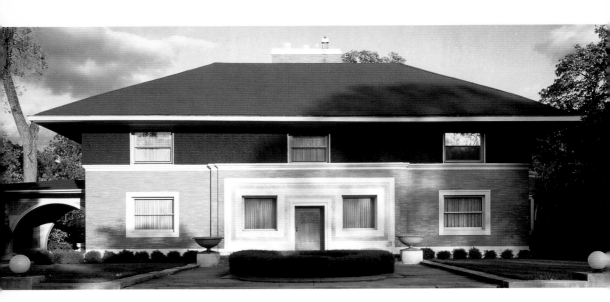

Independence

In the summer of 1893, having left Adler & Sullivan, Wright and his friend Cecil Corwin opened an architectural practice in downtown Chicago. In the mid 1890s, he shared offices with other young architects, though still drafting in Oak Park. At this time, Wright was definitely not a lone wolf. On the contrary, he was very much a part of the architectural avant-garde of Chicago, which regularly organized exhibitions, speeches, and panel discussions, and published articles.

The start of his career was promising: Already in May 1893, Wright had won the competition for a boathouse in Madison, Wisconsin with a draft that he had designed while still at Sullivan's. In the following years he built many residences, most of them in the vicinity of his own house in Oak Park. The marriage with Catherine Lee To-bin, whose parents belonged to the "upper crust" of this green suburb, had helped him make valuable contacts. Drawings for larger projects, like the ten-story office building for the American Luxfer Prism Company, which he did not advance further, were published in architectural journals.

In the very first year of his work as a free-lancer, Wright constructed his breakthrough building: The home for the wealthy publisher William H. Winslow in the fashionable suburb River Forest. It is a two-story building with a strictly symmetrical front façade and, in contrast, an asymmetrical and sprawling rear façade. The substructure consists of Roman brick on the first level and dark terracotta on the second, and is interrupted by double-hung windows. The overhanging roof with deep eaves emphasizes the horizontal.

Winslow House, River Forest, Illinois, 1893, front view

Winslow House is a rare example of the stylistic influence of Louis H. Sullivan: The idea for the foliage ornament framing the entrance is obviously taken from Sullivan's Wainwright Monument erected in 1892 in St. Louis. The differences in the design of the ornaments are revealing, however: While Sullivan's design showed closely intertwining plants, Wright preferred an abstract geometrical pattern.

The main entrance is embedded in a stone panel decorated with an ornamental frieze. Winslow House already shows the basic elements of the further development leading to the Prairie Style. Wright should achieve his breakthrough with this style in the beginning of the 20th century: The broad, overhanging roof dominates the house and lets it appear lower than it is; the façade is dominated by a design underlining the horizontal. Open spaces mark the interior of the house: The hearth stands at the core of the dwelling, rooms of different height separate the different living spaces from one another.

How radical the tripartite façade of Winslow House appeared to contemporaries is illustrated by the comment of a subsequent client, Nathan G. Moore, whom Wright quotes in his autobiography: "We want you to build a house ... but I don't want you to give us anything like that house you did for

Below:
**Moore House,
Oak Park, Illinois,**
1895,
view from the garden

Moore House originally had a Tudor-style wood frame façade.

The first floor was reconstructed by Wright after a fire in 1922.

Above:
Louis H. Sullivan
**Charlotte Dickson
Wainwright Monument, Bellefontaine
Cemetery, St. Louis,
Missouri,** 1892

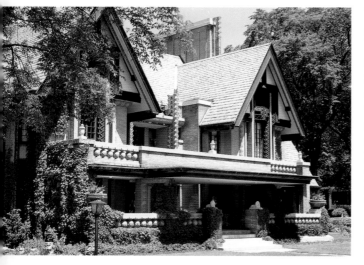

Winslow. I don't want to go backstreets to my morning train to avoid being laughed at." Daniel Burnham, on the other hand, one of the most influential persons in the Chicago architecture scene, was impressed. In the spring of 1894, he offered Wright a marvelous scholarship: He was to study for four years at the École des Beaux Arts in Paris and two more years in Rome. Upon his return, a position in Burnhams company would be guaranteed. But Wright turned the offer down. He wanted to find his own path, and he did not want to leave his family.

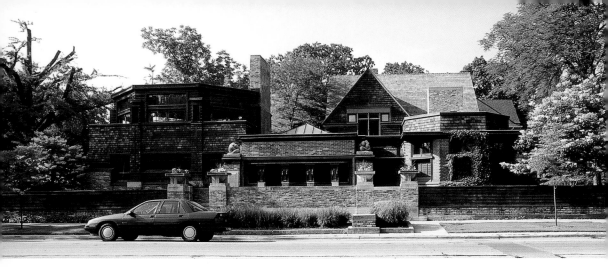

Oak Park

During his time in Chicago, Wright always kept an office downtown, although at often changing locations. However, his refuge in the green suburb Oak Park soon became the center of his life and work. He had bought a piece of land there in 1889 and built a house that finally was enlarged and remodeled by the addition of several annexes. It became a complex building with interlocking parts.

Frank Lloyd Wright's house and studio in Oak Park, Illinois, 1889-1895, view from Chicago Avenue, the studio in the foreground, behind it the living room; bedroom on the first floor of the house (below).

At a first glance, Oak Park did not seem especially original because of its orientation on the type of country house that was the fashion on the American east coast at the time. And yet, in a couple of details, Wright did make his architectural position clear: The main front with the pointed gable had a conventional design, but Wright broke with traditional symmetry by moving the main entrance to the right bay. The very large gable promised protection and shelter.

The fireplace and the kitchen formed, back to back, the core of the house. The rooms were connected by wall openings with sliding doors. A string course ran around the walls at the level of the doortops at about 6' 3'', reducing the height of the rooms to a human measure without making the ceilings so low as to seem threatening.

Wright almost doubled the original living area of the house by building

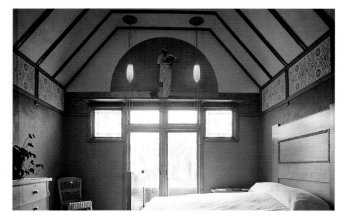

an annex at the side and the rear because he needed space for his rapidly growing family.

His first son Lloyd (born 1890) was followed by five other children: John (1892), Catherine (1894), David (1895), Frances (1898) and Robert (1903).

In 1893 he built a playroom on the first floor with an unusual barrel-vaulted ceiling. It was not only used as a children's room. The family often gave parties or staged theater plays there. Wright had a grand-piano built into the gallery of the room. In order to save space, the piano was integrated into the wall. The strings went through a crate in the adjacent staircase. Wright played

Beethoven until late at night. All of his children learned different instruments, which they played in the playroom or at concerts.

In 1895, the multifaceted studio complex followed as the next addition to the house: Wright wanted to unite his family life and his work under one roof. It consisted of an entrance hall, an octagonal library for meetings with clients, an office for Wright, and a two-story office for his employees with an octagonal ceiling.

Wright's favorite Sunday pastime in Oak Park was to rearrange the furniture. This way, his house probably never left the stage of a permanent provisional arrangement.

Frank Lloyd Wright with his family on the steps of his house in Oak Park, 1890

The photo was made shortly after the family moved in in 1890. Wright – with a mustache – is sitting to the right in the front of the picture, behind him his sister Maginel. Wright's wife Catherine can be seen in the middle holding their first son Lloyd. Seated behind them is Wright's mother Anna Lloyd Wright. His cousin Mary is on the far right of the picture.

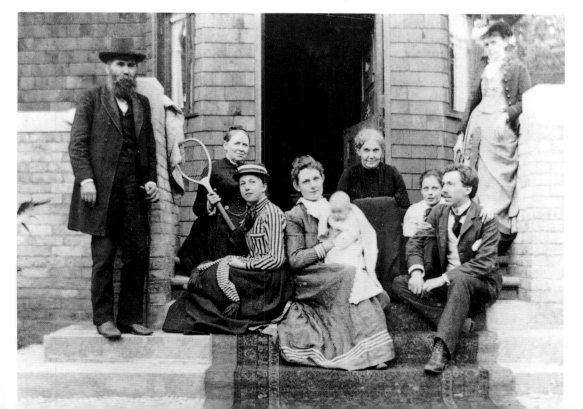

Steps toward the Prairie House

Searching for his own unique style in the 1890s, Wright's development was far from stringent. He took up several influences, experimented with forms and effects. His early buildings show historicist elements, pictorial aspects, and the rich orna-

Below:
**Williams House,
River Forest, Illinois,**
1895,
front view

Williams House gives an overall picturesque impression. The strong emphasis on the horizontal, a characteristic of the Prairie Style, is already noticeable.

stead of doors. The unusual geometrical shapes that should mark his later works already appear in the 1890s: The floor plan of the Romeo and Juliet Windmill (1897) in Spring Green, for example, reveals an octagon interlocked with a diamond.

Wright had quite a number of commissions and led a very active social life. He regularly gave speeches and

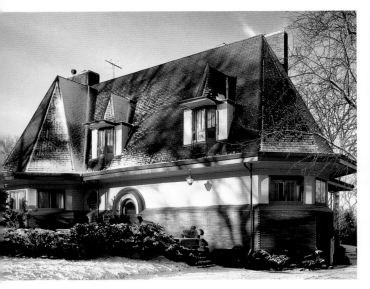

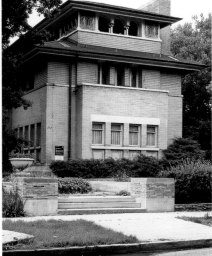

mentation of the buildings of Louis Sullivan. And yet, some characteristics of the Prairie Style of his later years, which had already been present in the Winslow House (see page 18), slowly became more dominant: the broad overhanging roofs, the emphasis on the horizontal, the cruciform floor plan centered around the fireplace, the flowing transitions between the individual rooms only divided by screens in-

Above right:
**Heller House,
Chicago, Illinois,**
1896,
front view

Here too, the horizontal is dominant. The rhythmically grouped windows on the first floor are placed on a cornice. The roof is flat.

displayed his works and designs in the annual exhibitions of the Chicago Architectural Club. He spread his design concepts and philosophy for architecture in articles for newspapers and popular journals. As early as 1900, Wright's reputation had grown to popularity and high esteem. A member of several clubs, who liked to entertain and loved fashionable living, he was regularly discussed in the gossip columns.

The salaries of his employees and the invoices of his suppliers, but also the ones of the baker or butcher in Oak Park, however, sometimes remained unpaid for months. His checks bounced often, and the sheriff was a regular visitor at Wright's – collecting debts.

Wright did not only enjoy his appearances in society, but he also loved life in nature. On his black

Below:
Furbeck House, Oak Park, Illinois, 1898, front view

The cruciform plan is emphasized vertically by the narrow third floor. The entrance is removed from the main axis.

poems by John Keats, for which Wright designed the front page and, in 1897, The House Beautiful, a book by the Unitarian minister William C. Gannett that came with hand-drawn page decorations by Wright. Following the concerns of the English Arts and Crafts movement, it laid great importance on functional beauty and the simplicity of forms in architecture and ap-

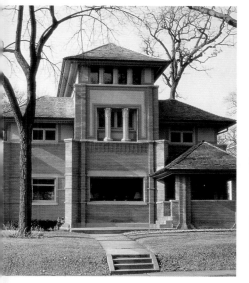

horse Kano, he roamed the then still undeveloped landscape near Oak Park, or he drove around in his handcrafted yellow sports-car.

The publishing house Auvergne Press remained a short episode. Wright had founded it together with Winslow, who sponsored the project. Wright himself took the position of chief designer. Only two books were printed in limited edition on a handpress: a volume of

Above:
Bradley House, Kankakee, Illinois, 1900, front view

Bradley House, built for the sister of Warren Hickox to the south of Hickox House, also functioned as a prototype for the Prairie Style. Wright introduced a very similar design in the *Ladies' Home Journal* in 1901.

plied arts. Although Wright rejected the idea of an egalitarian community of artists, he would later gather a group of artists from various areas of art around him in Oak Park and in Taliesin. The Arts and Crafts movement, which also counted Chicago artists, rejected the deployment of machines, whereas Wright welcomed modern technology as the tool of the artist in his article The Art and Craft of the Machine.

A Philosophy of Fine Art

Whatever we can learn from God, we can learn from God's body which we call nature.

Frank Lloyd Wright, 1909

The famous American architect and theorist Philip Johnson once called Wright an architect of the 19th century. Referring to an architect whose life and work was mainly in the 20th century, this statement sounds unfair, and was probably meant to be so. And yet, it is true, since Wright's understanding of architecture was mainly formed by the beginning of the 20th century. It was not to change fundamentally. This might be a surprise in view of the great diversity of styles in his work and the many turning points in his life. However, Wright's writings show an astonishing continuity.

In his essays and speeches, Wright did not cease to emphasize the fundamental principles of "organic architecture:" moral truth and inspiration won by nature. In contrast to his teacher Sullivan or to the Art Nouveau architects, he never simply depicted nature in a stylized form, but geometrically abstracted the forms of nature.

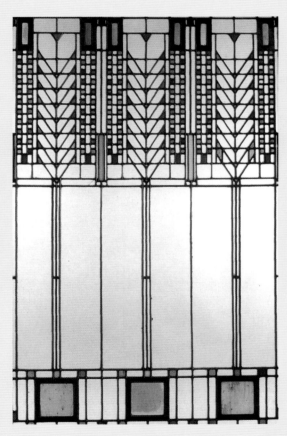

In order to understand Wright's work, it is necessary to understand the foundations of his art philosophy. It is rooted in the ideas of the American philosopher Ralph Waldo Emerson. Emerson's works were read frequently by Wright's family in his childhood. Their influence can be seen down to the missionary language of Wright's own writings. Emerson praises individuality and democracy, and the integrity of the creative person. Wright realized this romantic ideal of a genius, transcending the mediocre masses to the point at which it almost became a caricature. Visible nature is for Emerson only the manifestation of an inner and eternal beauty – and thus of the divine spirit. It is the task of man and especially of the artist to recognize this divine content of nature, to abstract it and thus lead it to a higher spiritual level. The outer nature is therefore for Emerson

Left:
Wheat-Window of Martin House, Buffalo, New York, 1904

Molding at the top:
Hollyhook-ornamentation of Hollyhock (Barnsdal) House, Los Angeles, California, 1917

merely the raw-material the artist should use to create a truer image of the divine, which is beauty. Therefore art is a richer expression of the divine than pure nature.

Consequently, it could not have been Wright's intention to portray visible nature. He wanted to capture its essence, its divine beauty in his buildings. On this philosophical foundation, Wright developed his art theory in the essay *A Philosophy of Fine Art* (1900). The notion of "conventionalization" is in its center. What Wright means with this concept is concentrating natural beauty to its essence, that is its immanent immortal principle. "Civilization means for us a conventionalizing of our original state of nature, it is here that the work of art is inevitable." In his artistic work, Wright sought the unity of truth and beauty, of moral and aesthetic. All of his buildings, as varied as they may be, are an expression of this search. And this is why Wright used moral concepts so often when speaking about architecture: "because beauty is in itself the highest and finest kind of morality so in its essence it must be true."

Wright used geometry as the key to beauty and truth. The fact that geo-

metry is underlying the divine principle of nature is something that Wright had learned as a child from the educational blocks of the pedagogue Froebel. Wright associated the various geometrical

for aspiration, the square for integrity and the spiral for organic process. In his attempts to express the divine, geometry was Wright's grammar, an organic integrity that was "the elemental law and or-

strongly abstracted natural form and why he explicitly rejected its depiction as a faithful copy. The many stylistic changes in Wright's work can also be explained by his concept of nature. Nature shows itself in uncountable variations, and everything that the artist finds in nature can be taken up, concentrated, and abstracted. Conventionaliziation he called the "process of capturing essence ... for the purpose of preserving it indefinitely." The key to organic diversity to him lay in the eternal search for new forms of expression. Wright always felt the urge to create new things, to prove his genius. He wanted to be first in everything and in all areas. He was always on the lookout for new forms, new materials and was testing the boundaries of the known.

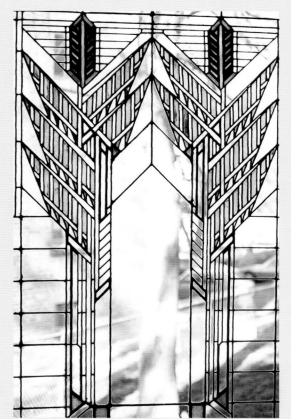

shapes with definite ideas in his essay *The Japanese Print:* The circle stands for infinity, the triangle for structural unity, the spire

der inherent in great architecture," as he defined it. This clarifies why Wright, who often described his art as organic,

Tree of Life Window of Dana House, Springfield, Illinois, 1903

First Bloom

1901-1910

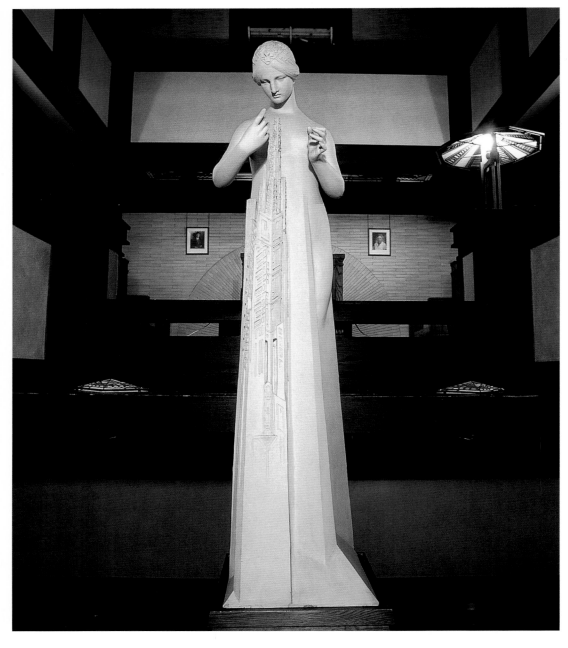

In 1901, Wright published two designs for family houses in the widely read Ladies' Home Journal. The two floor plan models, which he introduced, were the ones he would use in variation in all the residential houses of the following years. The widely flaring hip roof became a kind of trademark for these so-called Prairie houses. Several residences for the upper-middle class of the Chicago suburbs were built in rapid succession. The exemptions are the luxurious mansions Dana House in Springfield, Illinois and Martin House in Buffalo, New York.

The two large commissions of this decade were also important: The administration building for the Larkin Company is a brick building hermetically sealed from the outside world with numerous technical innovations. For the first time Wright moves the roof support from the corners of the building to the center, thus freeing the walls from their support function. He perfections this system with the Unity Temple in Oak Park.

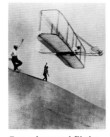

Experimental flight of Orville Wright

Frank Lloyd Wright in 1903

1901 The Nobel Prize is awarded for the first time. One of the winners is Wilhelm Conrad Röntgen for the invention of the X-ray. The American King Camp Gillette invents a razor with a disposable blade.

1903 Orville and Wilbur Wright carry out the first steered motor flight. In a Chicago theater, 600 people die in a fire.

1905 The first cinema of the USA opens in Pittsburgh.

1906 An earthquake destroys San Francisco.

1909 The US-American Robert E. Pearly is the first man to reach the North Pole. The first color film in cinemacolor is shown in New York.

1901 Wright publishes two designs for residences in the *Ladies' Home Journal.*

1902 Wright builds Willits House in Highland Park, Illinois.

1903-1905 Larkin Administration Building in Buffalo, New York.

1904-1906 Unity Temple, Oak Park, Illinois.

1905 Voyage to Japan.

1907-1908 Wright builds Coonley House in Riverside, Illinois, the largest of the Prairie houses.

1909 Robie House in Chicago, undeniably the masterpiece of the Prairie house era. Wright goes to Europe with his new partner Mamah Borthwick Cheneh.

1910 Wright lives in Florence and Fiesole, Italy. The monograph *Ausgeführte Bauten und Entwürfe (Studies and Executed Buildings)* is published in Berlin. It initiates Wright's international breakthrough.

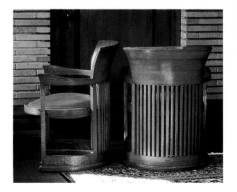

Opposite:
Allegory of architecture – statue for Dana House, Springfield, Illinois, 1903

Right:
Chairs for Martin House, Buffalo, New York, 1904

The Breakthrough

Wright did not achieve his breakthrough only through realized architectural projects, but with a promise for the future – two designs that he had published 1901 in the nationally distributed magazine *Ladies' Home Journal*: "A Small House with Lots of Room in it" and "A Home in a Prairie Town." In the accompanying text, Wright explained his concept: "The outside is strongly and obviously connected to the surroundings and takes up the quiet space of the wide prairie. The low terraces and the low overhanging eaves emphasize this quiet open space and perfection the harmonic relations." The two designs mainly differed in their outer appearance, especially in the form of their roofs: One showed a relatively steep saddleback roof like Hickox and Bradley House (see page 15), the other, however, had a hip roof with less inclination. The floor plan of the

Heurtley House, Oak Park, Illinois, 1902, front view

The house built for the banker Arthur Heurtley is only half a block away from Wright's Oak Park home. It seems like a fortress: There are no windows in the base, the arched entrance is removed from the middle axis and almost hidden behind the wall around the terrace. The windows are directly under the roof, which has a very low inclination. The walls are made from Roman brick, suggesting board and batten. The living area is above ground, the servants' quarters are on the first floor.

houses differed in the arrangement of the living rooms, which were cruciform in the one case and T-form in the other. Until 1900, Wright had produced an individual design for each house. Now he had two basic models that he could vary. All of the residential houses that Wright built in the following years were developed out of these two floor plans. Following the publications in *Ladies' Home Journal*, Wright soon received numerous commissions. Several convincing residences were built in rapid succession, most of them in the suburbs of Chicago: Thomas House, called "The Harem" (1901), which almost gives the impression of a fortress; the generous, brick-faced Dana House (1902), whose leaded glass windows have become famous (see page 17); Heurtley House (1902), which captivates with the horizontal layering of narrow brick bands; and the plastered Fricke House (1901), one of the few three-story residences

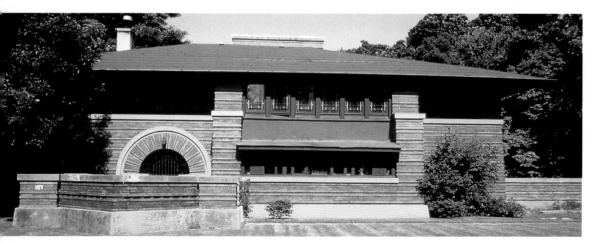

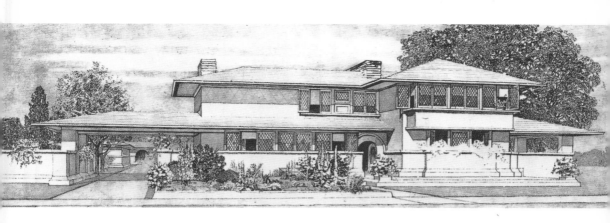

that Wright designed (see page 41). In contrast to most of the houses, Willits House (see page 35) was erected on a large piece of land. With its cruciform plan, cantilevered roof, and light plastered surface framed by dark wood, it became the ideal model for the early Prairie house.

Wright focused on fighting against the box-shape: For the inside of the house that meant breaking up the rigid divisions between rooms, for the outside it meant the extension of the house into the surroundings. These ideals, which Wright later claimed as his inventions, however, were not new. Already the most famous American architect of the time, Henry H. Richardson, had indicated the different living areas by different ceiling heights. The hidden entrance and the low overhanging eaves can be found in the works of British architects, who were influenced by the Arts and Crafts movement. Wright knew their buildings from pictures.

Project for the
Ladies' Home Journal,
1901

This house with a relatively flat hip roof and overhanging eaves became prototypical. In later years, Wright hardly ever used the steep saddleback roofs of the other project published in 1901.

Dana House,
Springfield, Illinois,
1902, front view

The house was built as the luxurious mansion of the million-dollar heir Susan L. Dana. Wright integrated remaining parts of the previous house. He designed a two-story studio for exhibitions and receptions.

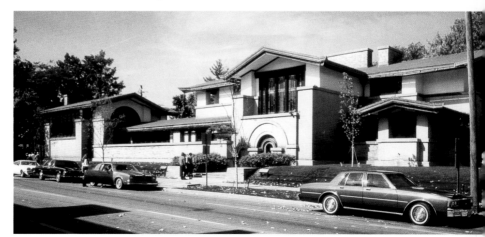

Re-inventing the Office-Building

In 1902, Wright was commissioned his largest building up to then: He was to design an administration building for the mail order department of the Larkin soap manufacturer in Buffalo, New York. It was built between 1903 and 1905 and torn down in 1950.

The inhospitable surroundings inspired Wright to develop a totally new concept. The office building was erected in an industrial area, surrounded by railway tracks, storage buildings, and factories. Nevertheless, the employees should be able to work in a light and airy space. This is how Wright decided to isolate the building from its surroundings. He created an inward-looking, hermetically sealed brick block.

The core of the rectangular floor plan for the building made of brick and hewed stone was the atrium. It was as high as the entire building and was lit by a glass roof. Around the atrium, there were open galleries, each lit by the skylights high overhead. This way, all workplaces were lit sufficiently, but the view outside was blocked. Apart from the founder of the company, Lar-

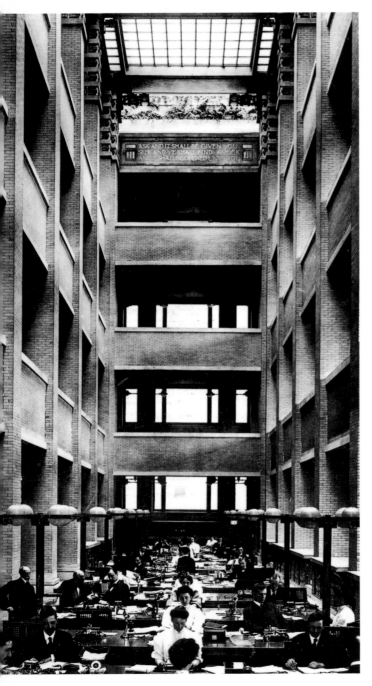

Left:
Working in the Larkin Administration Building in Buffalo, New York, photo, 1905

Atrium and open galleries built a nave-like space for which Wright designed an air-conditioning system.

I made many new inventions ... Nearly everything was new but the law of gravity and the idiosyncrasy of the client.

Frank Lloyd Wright, 1957

kin, and his sons, who had their own offices, managers and employees were placed in the large main floor that was only divided by the galleries.

For safety reasons, Wright moved the free-standing stairwells into four massive pylons on the corners of the exterior. Wardrobes, lavatories, and community rooms were united in a three-story annex. A separate entrance connected the main building and this annex, a model that Wright was to develop further in Unity Temple, Oak Park (see page 38). The air supply came through an air-conditioning, which drew in air heavy with coal dust on the roof, cleaned it, heated or cooled it depending on the season and then fanned it into the inside of the building. The Larkin Building was the first office building whose air was exclusively supplied by an air-conditioning system.

Wright integrated a restaurant on the top floor, a conservatory, and a library. He also designed the furniture, which was new in many aspects: All of the custom-made office furniture was made of metal: the filing cabinets were fit into the brick walls, there were multiple chair-desks, the glass doors were framed in metal, and the floors were cast in magnesite, a kind of concrete. New was also the idea of hanging the closets onto the walls, to simplify cleaning.

Larkin Company Administration Building, Buffalo, New York, 1903

Wright placed the stairwells into four independent massive corner pylons. From the outside, the width of the atrium is marked by pillars in front of the short sides of the building. Atlas statues carrying globes were put on top of them. The hermetically sealed view from the outside was predominantly criticized. One critic deemed the building a "monster of awkwardness."

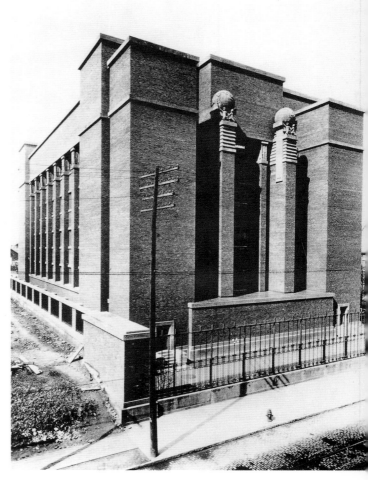

The Prairie Style

In all their diversity and individuality, the residences that Frank Lloyd Wright built in the first decade of the 20th century – the so-called Prairie houses – still share:

The Unit-System
The basis for the construction of all of the Prairie houses was the "unit system" developed by Wright. It was a method of organizing a plan with the help of a geometrical grid that enabled him to maintain uniform dimensions and orchestrate axes and directions. One unit was the space between two window frames. Wright gridded his draft paper and then drew all of the walls, pillars, and even garden walls accordingly. This offered him a simple system for the organization of space which was suitable for lending a geometrical balance to his designs. The grid is only printed in the floor plans published after 1935. However, it is known from his employees that Wright already used this method of construction in 1901.

The Height of the Ceiling
The height of the ceiling is oriented at Wright's own height: "Taking a human being for my scale, I brought the whole house down in height to fit a normal one – ergo, 5'8 $\frac{1}{2}$'" tall, say. This is my own height ... It has been said that were I three inches taller than 5'8 $\frac{1}{2}$" all my houses would have been quite different in proportion. Probably."

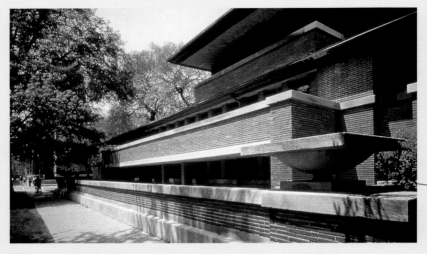

Breaking Up the Box Shape
"I declared the whole lower floor as one room, keeping the 'sleeping boxes' for the upper floor." Unnecessary doors disappeared, interior spaciousness brought an end to the cluttered house. As to the outside box-shape, Wright shifted the roof support to the inside of the house, thus freeing the outer walls from their supporting function.

Avoidance of Symmetry
The oftentimes arched doorways are never situated in the center, but often almost hidden. According to Wright, the "obviously symmetrical" would tire the eye too fast.

The Form of the Roof
The overhanging low roofs fix the houses to the ground. They signal shelter and security and relate the house to its surrounding landscape.

Above:
The dominance of the horizontal line reflects the landscape of the wide plains of the American Midwest.

Below:
The extended terraces, walls, and roofs integrate the house into the landscape. Wright built each house "natural to its prairie site." He raised the basement to the ground level, the living areas are usually situated on the second floor.

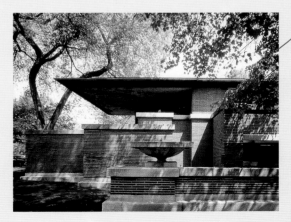

The floor plan

The arrangement of the rooms is also characteristic for the Prairie houses. The center is always formed by the fireplace opening to the living room. The entrance is always in the rear of the building.

For all further room divisions in all of his residences created in the Prairie house era, Wright simply varied the two floor plan types that he had introduced in the Ladies' Home Journal in 1901.

The first type, exemplified by Bradley House or Willits House, has a cruciform design with four main wings. Living room and kitchen are located on the main axis; the other axis is determined by the entrance with a roofed porch and the dining room connected to a veranda. The different living areas are accommodated in separate wings, all relative to the centripetal element, the fireplace.

The second type, realized in Hickox House, is different: The entrance leads to the living room passing the

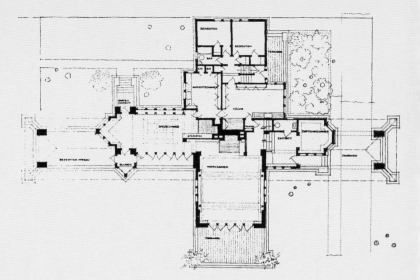

fireplace. The library and the dining room are behind the living room to the right and left, so that the floor plan forms a T-shape. The kitchen is in the angle between entrance and dining room.

Room Divisions

Strict divisions between interior rooms are broken up in both floor plans and substituted by screens. Only the part of the house in which the kitchen and the

servants' quarters are located is separated by doors from the rest of the house. The rooms of the living area are interconnected. The different ceiling heights are characteristic: Central gathering points in the house are emphasized by high, unfolding ceilings.

**Willits House,
Highland Park, Illinois,**
1902
Floor plan (above) and front view (below)

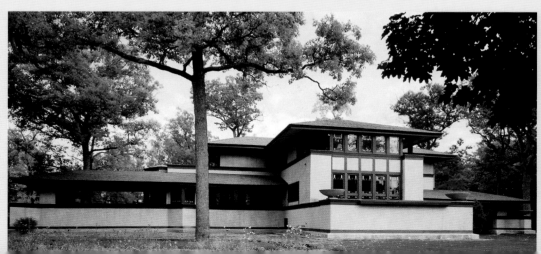

Robie House

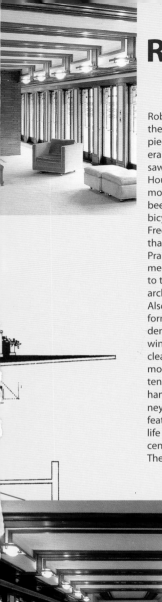

Robie House is considered the undisputed masterpiece of the Prairie house era even though Wright saw the luxurious Coonley House (see page 37) as more important. It had been designed for the bicycle manufacturer Frederick C. Robie. More than with any other of his Prairie houses, Wright formed the house according to the principles of his architecture.

Also here, horizontals are formative – from the garden walls to the line of windows and roofs. The clear lines create an enormous dynamic that is intensified by the overhanging eaves. The chimney provides an anchoring feature for the house, the life giving element in the center of the construction. The floor plan of Robie

House shows two narrow rectangles sliding alongside one another. The smaller one, to the rear, contained the entrance. The billiard and the playroom, the laundry and the boiler room are on the first floor. The living areas are on the second floor, sleeping quarters on the third. The front part of the building consists of one big room, which is only separated into living room and dining room by the fireplace and the staircase. A band of glass doors opens to the long and narrow balcony. The living room ends in a pointed bay leading to the terrace. Steel beams allow the flat roof to protrude almost 23 feet at this point, farther than in any other Prairie house.

For the first time in American architecture, the garage is not banned to the back of the premises near the stables but is inte-

grated into the building complex. It is located under the servants' quarters in the back of the house. Like in many of his houses, Wright also designed the entire furniture, the lamps, fabrics, and carpets for Robie House, and thus created a great overall composition. The house was nicknamed "The Battleship" due to its dynamic forms and its mechanic perfection; apparently, this pleased Wright. He saw Robie House as proof for the fact that machines are capable of producing outstanding results in the hands of an artist. How much Wright cherished Robie House became obvious when he intervened twice when it was to be torn down. "It would be like destroying a fine piece of sculpture or a beautiful painting," he said. In 1957, the American magazine *House and Home* elected it "House of the Century."

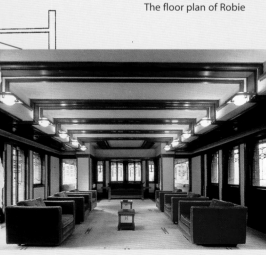

All illustrations:
**Robie House,
Chicago, Illinois,** 1909,
interior and exterior views,
drawing with floor plan

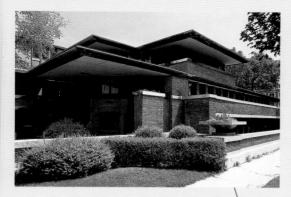

Left:
The unusually deeply overhanging eaves break up the "box shape" of the house and protect it from sun and precipitation.

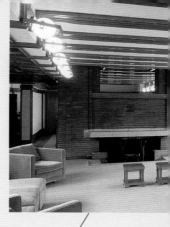

Right:
The fireplace is the core of the house -- a source of light and heat at the heart of the community.

Left:
The delicately ornamented leaded glass doors and windows flood the interior with a warm light and make curtains superfluous. They often show rising patterns abstracted from nature that symbolize growth.

Right:
The rooms interlock and are not divided by doors. Not only the smooth transition between interior and exterior of the house, but also the connection of the various living areas on the inside characterize the Prairie house. The houses once and again surprise by unexpected light effects and the alternation of low and dramatically high ceilings.

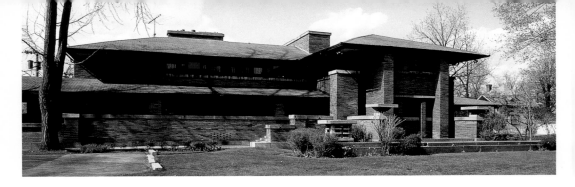

Luxurious Residences in the Prairie Style

During all of his life, Wright could count on friends and sponsors in financial emergencies. Over three decades, one of the most important of these sponsors was Darwin D. Martin. To him Wright owed numerous and important commissions, among them his first large one: the Administration Building of the Larkin Company (see page

Darwin D. Martin House, Buffalo, New York, 1904–1905, view of the front of the house (above) and ground plan (below)

The dining room (left on the plan) and the library (right) lead on to the sitting room. The entrance hall (bottom) and the roofed veranda make up the second axis. An open gallery leads onto the back of the property.

30), whose vice-president Martin was. They met in 1903 when Martin and his brother William were looking for an architect for William's house in Oak Park. Therefore, the house Wright built in 1904 and 1905 for Darwin D. Martin in Buffalo in fact was Wright's second Martin House.

The walls of the two-story house are made from Roman brick like the ones of the more famous Robie House, built four years later (see page 34). This house also features flat hip roofs. The living rooms are in the second floor and form a T-shape: Dining room, living room, and library are on one axis. Like in all Prairie houses, the entrance is at the rear, near the fireplace, which builds the heart of the house. The roofed veranda forms the fourth wing. An open gallery leads from the dining room to the stables, the garage, and a conservatory. Orlando Gianinni's stained-glass windows showing abstracted representations of the tree of life, designed by Wright, have also become famous (see page 24).

Coonley House, which Wright built from 1907 to 1908, is even larger

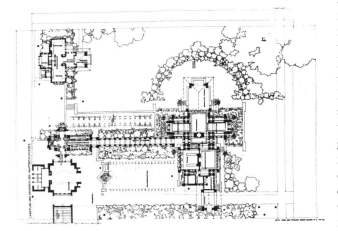

and juts out into the surrounding even more than Robie House. It was built on a spacious precinct. The commissioner was the Chicago factory owner Avery Coonley. In this house, which Wright in retrospect deemed his most important residence of the Prairie house era, the living area was also located on the second floor. Wright assigned each different function a different wing of the house: The central room is the large square living room, the fireplace is on the rear wall, the ceiling follows the pitched roof and thus unfolds like a tent. A large pool is in front of the living room. The dining room joins up to the north, the kitchen and servant quarters are to the rear, above the driveway. The bedrooms are in a separate wing to the south. This area is like a house

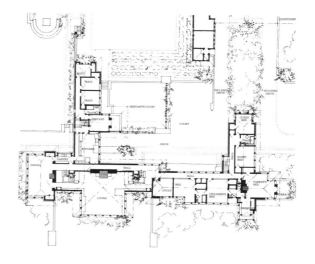

of its own, arranged around a fireplace in four wings. The playroom is beneath the living room. Stables, the Gardener's cottage, and a large garden also belong to the complex.

Above:
Coonley House, Riverside, Illinois, 1907, floor plan

The palatial Coonley House joins two cruciform floor plans to one large complex: the dining room to the right, above it the large living room; below, the servants' and kitchen tract with the driveway underneath it. To the left, there is a study and the bedroom wing with the children's rooms, the guest rooms (below), the master bedroom (left with the fireplace), and the dressing room (above).

Unity Temple

I knew I was at the beginning of something great, a great truth of architecture. Now architecture could be free.

Frank Lloyd Wright, 1952

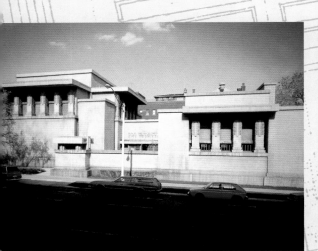

The new building for the Unitarian congregation in Oak Park was Wright's second largest commission after the Larkin Building (see page 30). In its floor plan as well as its elevation, Unity Temple was a further development and refinement of the experience Wright had gained with the Larkin Building. "A higher concept of architecture [had emerged]. Architecture not alone as "form following function" in Lieber Meister's sense but architecture for the spirit of man, for life as it must be lived today."
The construction work took three years, from 1904 to 1906. This was primarily due to the unusual building material Wright worked with: Building with reinforced concrete was a technique that was still in its experimental stages in Europe and the USA. The decision for the new material was a result of the tight budget: Concrete was cheapest. Only the wooden casts into which the concrete was poured were expensive. Using the casts several times saved money. And so Wright designed a square-plan building, a cube, or as he put it, a "temple," thus deciding against the traditional church type: a rectangular room that is entered through a large portal opposite the altar. Since, according to Unitarian beliefs, Unity Temple was more a meeting hall than a place of cult or worship, it has a very different lay-out. First of all, Wright separated the church, "Unity Temple", from the parish rooms used for secular activities, "Unity House". He put these into a second building that imitates the forms of the church but is lower, with a longer floor plan. The entrance hall is between the two blocks so that the overall floor plan is an H-shape, the basic shape of the Larkin Building.

Left:
Unity Temple, Oak Park, Illinois, 1904-1906, front view (left) and interior of the church (below)

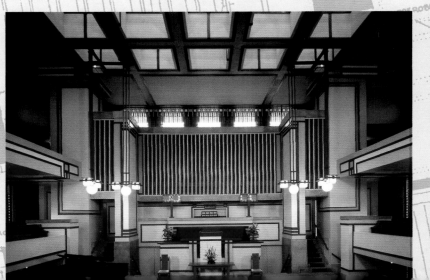

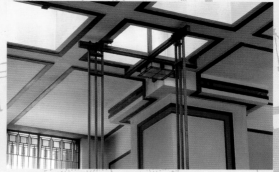

What is most unusual about the church is the structure. Finally, Wright had been able to consciously break up the "box shape," i.e. the principle of the walls supporting the roof. The outside walls no longer support the structure. The four free-standing square posts are the sole support, they hold the skylight in the flat roof. Freed from their structural burden, the walls become movable elements that shelter the room from the outside. Wright used this opportunity and pulled the walls back significantly. The effect is overpowering, especially due to the skylight that makes the room look like it is floating. The amber glass ceiling floods the room, so that even in bad weather, as Wright described it, there would be "a sense of a happy, cloudless day." Wright used the gained interior space for double tiers of alcoves on all sides and closed them off with low, flat overhanging eaves.

In contrast to the Larkin Building, the visitor does not enter the main room directly. From the entrance hall, the congregation descends to a lower lobby with corridors on either sides which then lead to a staircase in the far corners of the main hall of the church. The staircases are covered, so that latecomers wouldn't disturb the service. At the end of the service, wide doors behind the altar would swing open, so that the congregation could pass the pastor on the way to the main entrance hall. The church is surprisingly small. It seats only 400 people on the pews in the center of the room and in the alcoves. The whole complex is organized according to its functions: "the room inside is the architecture outside," Wright stated. The interior is determined by linear geometrical ornamentation: The long, flat bands and beams form squares and rectangles in asymmetrical arrangement. Wright seems to anticipate one of the most important art movements years before its time: that of the Dutch group De Stijl and of the painter Piet Mondrian.

**Unity Temple,
Oak Park, Illinois,**
1904-1906,
detail from the ceiling (top left), skylight in the church (top right), and floor plan (below)

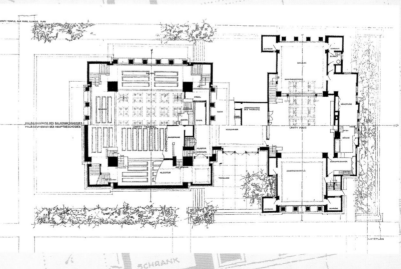

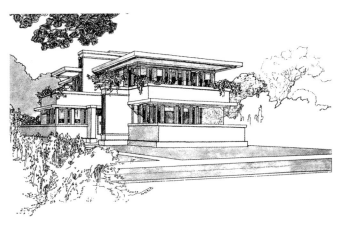

Escape to Europe

In September 1909, the Prairie house era found a surprising end when Wright passed on his practice to his young employee Hermann von Holst and traveled to Europe. There were probably several factors involved in this decision.

At the age of 42, Wright was a wealthy man leading a large and famous architectural practice. He had erected over 140 buildings and had presented around 50 further drafts. His style had found numerous imitators. His works were widely discussed. But compared to the renowned historicist architects with a "classic" education, Wright's commissions were modest. His work up to then consisted almost exclusively of residential designs which had been built in the suburbs and outskirts of Chicago. The Larkin Building (see page 30) had received predominantly negative critiques, and Unity Temple (see

Thomas H. Gale House, Oak Park, Illinois, 1909, design from the 1911 Wasmuth portfolio *Ausgeführte Bauten und Entwürfe von Frank Lloyd Wright*

Gale House was built in 1909. The dominant horizontal line created by a cantilevered roof already points to Fallingwater of 1936, one of Wright's most famous residences (see page 70).

Mamah Cheney, photo, undated

Artistic and cosmopolitain Mamah Cheney had studied letters and translated the works of the Swedish feminist Ellen Kay. She and Wright translated Goethe, the architect's favorite author.

page 38) had not been discussed at all by the national press. Subsequent commissions for larger projects had not materialized.

Wright had also come to an end artistically. He had perfectioned his style, and he had realized his architectural principle in an ideal form with Robie House (see pages 32-35) and Coonley House (see page 37). Now he was looking for new challenges: "Because I did not know what I wanted I wanted to go away."

On top of this, there was the affair with Mamah Borthwick Cheney, the wife of one of his clients. They had met in 1903 and had probably begun their relationship soon after. In 1908, Wright asked his wife for a divorce, but Catherine demanded to wait for at least a year. When

she declined again after the separation year, Wright escaped: In October 1909, he embarked to Europe with Mamah Cheney.

Wright and Cheney traveled first to Berlin, where the publisher Ernst Wasmuth wanted to publish a volume on Wright in his series of monographs. They checked into the hotel as Mr. and Mrs. Wright, a fact that was discovered three weeks later by an American reporter. It promptly made the front-page of the Chicago Tribune: The first scandal was born.

What had originally been planned as a small Wasmuth Volume ended up as two portfolios: *Ausgeführte Bauten und Entwürfe von Frank Lloyd Wright (Studies and Executed Buildings)* was published in 1911. From 1910 on, Wright worked on the drawings and the text, in which he set out his positions on architecture, with his son Lloyd and other assis-

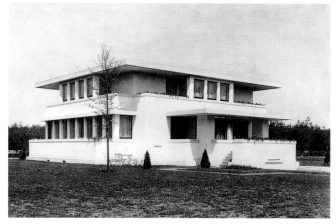

tants first at a villa in Florence and then at nearby Fiesole. But Wright did not want to stay in Europe permanently. While his work was being absorbed enthusiastically by the young generation of architects in Europe, Wright returned to his family at Oak Park in October 1910, but definitely left his wife in March 1911. A new phase in his life began.

Robert van't Hoff
**Henny House,
Huister-Heide,
The Netherlands,**
1916, outside view

Wright's Gale House obviously served as a model for the Dutch architect and member of the artist group De Stijl.

**Fricke House,
Oak Park, Illinois,**
1901, front view

Fricke House, erected in 1901, especially attracted the attention of young European architects. It is one of the rare three-story buildings of Wright. The vertical dominates the horizontal – very untypical for Wright. The plain plaster surface reminds of the European buildings of the time.

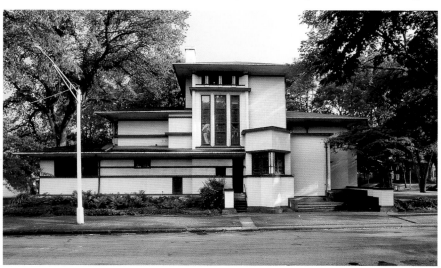

Years as an Outsider 1910-1929

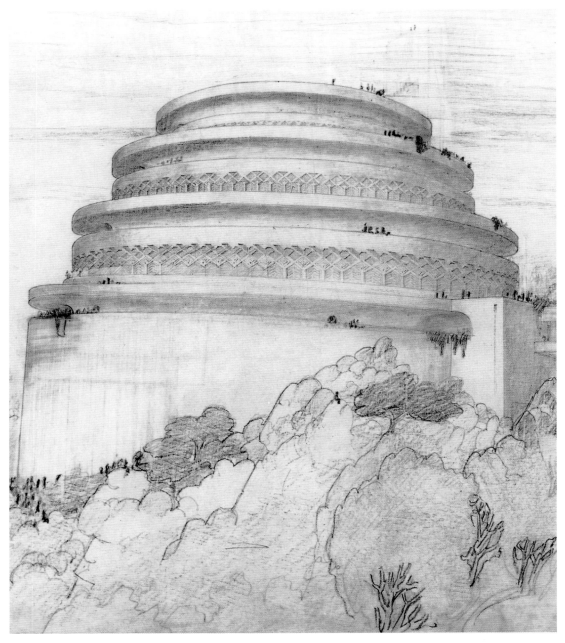

In 1910, Wright returned from Europe to Chicago. He bought a piece of land near Spring Green, Wisconsin, and built the new living, working, and farm complex Taliesin for his companion Mamah Cheney and himself. He continued to design residences and was commissioned a pleasure palace with restaurant facilities. The idyll in Taliesin ended in a catastrophe: In 1914, an employee ran amok killing Mamah Cheney and setting fire to the house. Nevertheless, Wright rebuilt Taliesin.

He spent 1917-1922 predominantly in Tokio building the large Imperial Hotel. At the same time he designed the spacious Hollyhock House in Los Angeles. From 1923 to 1924, he worked in Los Angeles designing four residences in the innovative textile-block construction method.

In the mid 1920s, Wright entered into what was to be the most severe crisis of his life: He was divorced twice, was hunted by the police and the tabloids, and was not able to realize a single construction for several years. Instead, he developed some visionary designs.

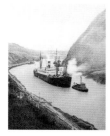

Opening of the Panama Canal

1914 The Panama Canal is completed as the first water passage between the Atlantic and the Pacific Ocean. The First World War breaks out.

1917 USA declares war on Germany.

1918 End of the First World War.

1919 The re-ordering of Europe is discussed at the Versailles Peace Conference.

1920 Women's suffrage in all states of the USA.

1927 The American Charles Lindbergh is the first to fly over the Atlantic Ocean non-stop.

Frank Lloyd Wright in 1924

1910 Wright returns to Chicago.

1911 He builds Taliesin in Spring Green, Wisconsin.

1913-1914 Wright builds Midway Gardens, Chicago.

1914 Taliesin burns down and Mamah Cheney is killed. Wright meets Miriam Noel.

1917-1921 Wright builds Hollyhock House in Los Angeles.

1917-1922 He lives in Tokyo and builds the Imperial Hotel.

1923 He is divorced from Catherine and marries Miriam Noel. Wright's mother dies.

1923-1924 Practice in Los Angeles. Four houses are built in textile-block construction.

1924 Separation from Miriam Noel. He starts a relationship with Olga M. Hinzenberg. Wright's mentor Louis Sullivan dies.

1925 Taliesin burns down again, Wright is forced to sell his Oak Park home.

Opposite:
Design for the Gordon Strong Automobile Objective, Sugar Loaf Mountain, Maryland, 1925

Right:
Stein for the Midway Gardens pleasure park, Chicago, Illinois, 1913

Taliesin

Wright returned to Chicago in the autumn of 1910. He remodeled his Oak Park house so that it contained two separate parts: The house for Catherine and the children and the studio for himself. But the rift between him and Catherine was final. For this reason, Wright decided to buy a piece of land in Spring Green, the valley of his ancestors. To his friend and sponsor Darwin D. Martin, who lent him the money for the project, he wrote that he wanted to build a house for his mother. But this was only the partial truth. Mamah Cheney returned to the USA in the summer of 1911, after the separation year for Wright and Catherine was over. Wright moved in with her in December 1911.

He called his new home Taliesin which in Welsh means "shining brow" and is the name of a legendary hero poet of the Middle Ages.

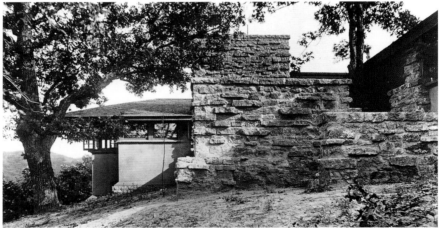

In the margins:
Window for Coonley Playhouse, Riverside, Illinois, 1912

Wright built an addition to Coonley House for theater performances in 1912. The glass mosaic windows are in many-colored geometrical designs.

Above:
Taliesin, Spring Green, Wisconsin, 1911
View before the fire of 1914

Nestling into the brow of a hill, Taliesin thrones above the valley like a feudal stone fortress. Wright used local wood and limestone as building materials.

In the legend the poet experiences several fantastic metamorphoses. Taliesin sins but is gifted with the insight into the workings of the divine and receives his inspirations from nature. Wright obviously identified with this character at the beginning of a new phase in his life and work. From a small beginning, Taliesin soon developed into an extensive self-sufficient living, farm, and office complex with several individual buildings.

The facility is similar to the recent Prairie houses from the outside, the floor plan, however, is freer.

Officially, Wright still lived in Oak Park, but he visited Mamah Cheney and his mother Anna in Taliesin as often as he could. The tabloids soon found out about the "love-nest," and it was just what they had been waiting for.

Wright was shunned in the conservative circles in Oak Park, but now he consciously adapted the role

new course: He designed Midway Gardens in the south of Chicago, an extensive pleasure complex. But his luck and happiness soon ended in a catastrophe. On August 14, 1914 – Wright was in Chicago at the time – the cook ran amok: he set fire to the house and killed Mamah Cheney, her two children, and four employees with an ax. The murderer died two months later in prison because he had refused to eat.

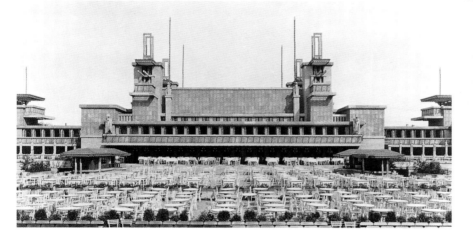

of an outsider. The few commissions that he still received he treated with little inspiration. Instead, he wrote the essay *The Japanese Print* (1912), in which he not only talked about his much admired Japanese prints but also stated his views on the method and social function of architecture and described the meaning of geometrical shapes.

In 1913, he was finally awarded a large commission again, which made it possible for him to adopt a

Midway Gardens, Chicago, Illinois, 1913-1914, view of a terrace with beer garden

With this project, Wright finally had the opportunity to test a new architectural language. The huge complex of terraces and halls has a strictly symmetrical structure and yet is playfully designed. The ornamen-

tation of the facility, which is predominantly made from brick, is remarkable: The concrete is adorned with abstract geometrical patterns. Wright designed all of the furnishings, even the china and the tablecloths. Due to the Prohibition, the facility was not used very long; it was finally torn down in 1929.

Reconstruction

Wright had been emotionally shattered after the fire in Taliesin, but then he threw himself into reconstructing it. Taliesin II, as he called it, became substantially larger: The apartments for himself and his mother were separated, and the studio complex, which had not been destroyed, was enlarged. In time, more living quarters for the employees, stables, and farm buildings were added. As before, he decorated his home with Japanese art: prints, ceramic, bronzes, and screens. Japanese prints were the only pictures that he accepted in the houses he built. Wright had become an expert for Japanese art over the years; he was one of the most important collectors of Japanese prints in the USA. Already in 1905 on his first voyage to Japan, he had acquired the foundation of his collection. In 1913, he returned to Japan again

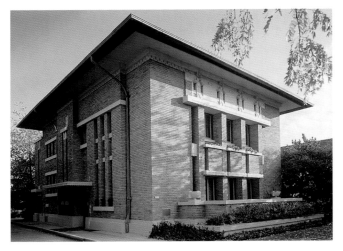

Bogk House, Milwaukee, Wisconsin, 1916, front view

A.D. German Warehouse, Richland Center, Wisconsin, 1915, front view

for five months, this time to secure a large commission: the new Imperial Hotel in Tokyo. But the owners took their time with the official commission. So Wright was back to building residences in the Midwest of the USA. Between 1911 and 1917, 40 buildings were erected after his plans: residences, apartment buildings, holiday retreats, a small

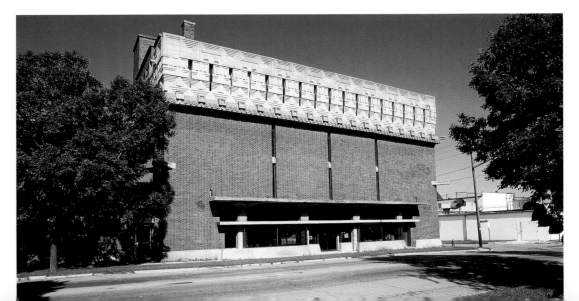

settlement, and a warehouse. He often left the site management to his employees, who continued operations in the office in Oak Park. Wright departed from the Prairie Style in his design and moved in a new direction toward symmetrical rigor and self-contained block types. He officially broke with the Prairie school in 1914 in an article, "In the Cause of Architecture, II" for the magazine *The Architectural Record*. He accused the architects continuing his old style of empty imitation. Therefore, the fact that the Prairie School became unfashionable around 1915 did not matter to him. The architects of the Prairie School were for the most part former employees of Wright, some of whom had departed in a quarrel. Wright accused them of being ungrateful – it was always hard for him to let go of employees who wanted to follow their own directions.

Shortly after the catastrophe in Taliesin, Wright received the compassionate letter of a sculptor he didn't know. She visited him shortly after. Maud Miriam Noel was two years his junior and financially secure due to a rich ex-husband. She was a sophisticated and spirituel woman who moved in all circles of society. However, she was also stricken with unhappy love affairs and a touch of tragic. Like Wright, she was an outsider. They became a couple before the end of the year 1914 and moved together although she had proven to be psychologically unstable early on. Now that Ta-

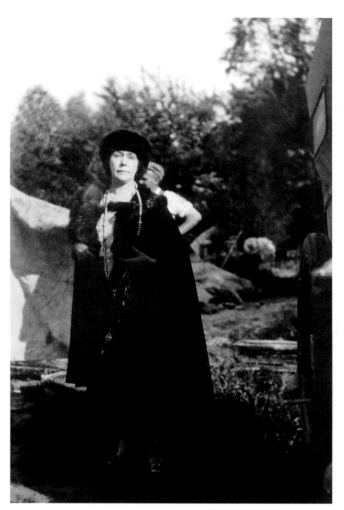

liesin once again had a lady of the house, Wright dismissed his housekeeper. She got her revenge by stealing his and Miriam Noel's letters and handing them over to the press. She also reported them to the police for immoral behavior. The charge was dropped, but the newspapers had once again gotten their money's worth.

Miriam Noel,
photo, undated

Wright was Miriam Noel's greatest love, but this didn't keep her from competing for the limelight with him. Unfortunately, she proved to be erratic, hypersensitive, and addicted to morphine.

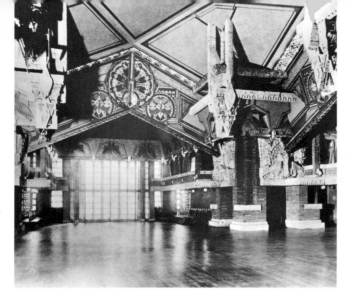

given up her sculpting in order to support Wright.

However, financial problems in the hotel construction became ever more pressing. Building dragged on for several years. Wright put the blame on his clients, while they increasingly complained about Wright's obsession with every little detail: Wright did not have the complicated ornamentation produced by machines; they were instead conscientiously realized in Oya-stone - a lava rock - by Japanese craftsmen, which took much longer.

Years in Japan

On his voyage to Japan in 1913, Wright had already attempted to get the commission for building the new Imperial Hotel in Tokyo in close proximity to the Imperial Palace. He was finally awarded the contract in 1916. Therefore, he spent most of the following six years in Japan. He did, however, cross the Pacific regularly to take care of projects like Hollyhock House (see page 50) in Los Angeles and Taliesin.

Wright and his companion Noel resided in a five-room apartment of the old Imperial Hotel, which had been built in the 1880s. He could always dispose of a limousine with a chauffeur. Wright enjoyed experiencing the Japanese culture, and also the relationship to Miriam Noel went well, apart from a few crises. She had totally

IImperial Hotel, Tokyo, Japan, 1917-1922, ballroom

Because of the danger of earthquakes in Tokyo, Wright devised an unusual construction: He separated the building into many different units which were connected by expansion joints. He put a concrete pillar under every unit which held it up like the hand of a waiter carrying a tray. The surrounding walls, too, were put on separate rows of pillars. In order to minimize the weight of the construction, Wright used hollow bricks for the walls and sheet copper for the roof.

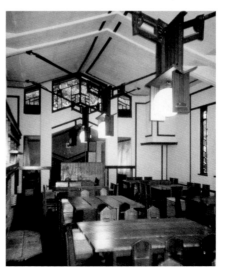

Jiyu Gakuen, Girls' School, Tokyo, Japan, 1921, dining room

Apart from the Imperial Hotel, Wright designed three residential houses and a girls' school in Tokyo during his stay in Japan. The dining hall of the so-called "School of the Free Spirit" is the largest and highest room in the school. The size of the furniture and of the five class rooms was adapted to the size of the children.

When the old Imperial Hotel burned down in 1922, Wright's clients pressured him to finish the new hotel as fast as possible. But a stroke of fate defused the situation: On April 26, 1922, Tokyo was hit by the strongest earthquake in 30 years. A lot of buildings in the neighborhood of the new Imperialo Hotel were destroyed, but the hotel itself remained untouched. Now, the clients proudly backed their architect. Only three months later, the construction work was completed, and Wright returned to the USA with Noel.

Only a year later, on September 1, 1923, there was another earthquake. The worst earthquake of the 20th century had a death toll of almost 100.000. Communication with Japan was interrupted for days, and first rumors in the American press said that the Imperial Hotel had been completely destroyed. Wright was in a state of anxiety, until the famous telegram of the hotel manager arrived: "Hotel stands undamaged as monument of your genius. Hundreds of homeless provided by perfectly maintained service."

IImperial Hotel, Tokyo, Japan, 1917-1922, outside view

The hotel was also designed in an H-shape. The banquet hall, the theater, dining halls, and private dining rooms were in the central area. The guest rooms and suites were in two long wings, which framed a garden with ponds. The facility was torn down in 1968, but a small part was rebuilt near Nagoya.

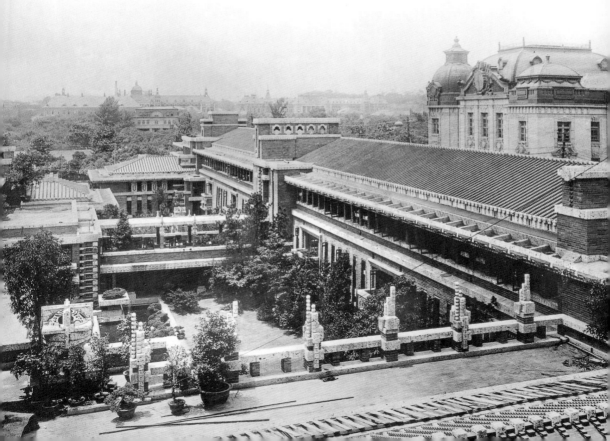

Hollyhock House

The spacious Hollyhock House in Hollywood is the most important building from Wright's years as an outsider. In 1917, he had taken on the commission to build an artists' colony on a large piece of land on Sunset Boulevard in Hollywood for the rich heir of an oil fortune, Aline Barnsdall. The complex comprised a theater and cinema, living quarters and studios. Wright saw this as a chance to build a "second Taliesin." But Aline

Barnsdall was too erratic and oftentimes unable to make decisions. She had also overestimated her finances. Only her house, a kindergarten, and two smaller houses were realized in the end. Wright stayed in one of them, the so-called Studio Residence B, after his return from Tokyo. The owner herself almost never stayed in Hollyhock. She donated the estate to the city of Los Angeles in 1927. Hollyhock House thrones on the

plateau of Olive Hill like a Mayan temple. In one of the first drafts, Wright had designed a kind of large Prairie house. In the end, it became a symmetrical, almost hermetic, monumental façade which is marked by the heavy flat roof and a continuous row of ornamental stones which have a native American air to them. After his return from Europe in 1910, Wright had started experimenting with exotic shapes, like for instance the

Secessionist school in Vienna did. Whereas the Secessionists took up Egyptian and oriental motifs to renew art, Wright, as a decidedly American architect, turned to the pre-Columbian Maya-ornamentation. The ornamentation in Hollyhock House was developed after Aline Barnsdall's favorite flower, the hollyhock, which the house was named after.
Due to the hot climate, Wright aligned the house

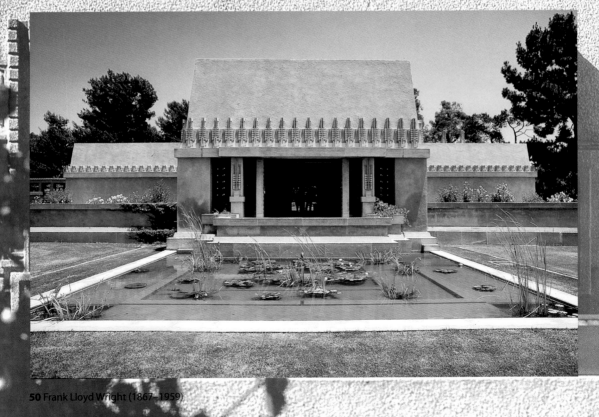

toward the inside. It opens around a green courtyard, which looks like an oasis. Water plays an important role everywhere in the house. It flows from a well-house to a large basin in the courtyard and a smaller basin in front of the fireplace in the living room, to basins in front of the living room windows and into a channel in front of the bedroom windows. The floor plan is arranged symmetrically around the courtyard. The central room of the one-story building is the living room with the adjoining music room and library. Entrance, dining room, kitchen, and servants' quarters are in the north wing. The guest rooms are in the south wing going off a gallery. The courtyard is open to the east but the ends of the wings are connected by a kind of bridge which contains the bedrooms of the family members. Wright designed the roofs, which were higher or lower depending on the various heights of the rooms beneath, as roof gardens which were accessible by stairs and bridges. Since Wright was not often in Los Angeles during the construction phase, he

passed on the site management to Rudolph Schindler, an Austrian immigrant who would later become one of the most important Californian architects.

Hollyhock House of Aline Barnsdall, Los Angeles, California, 1917-1921, outside view (left), entrance (above), living room with fireplace (below)

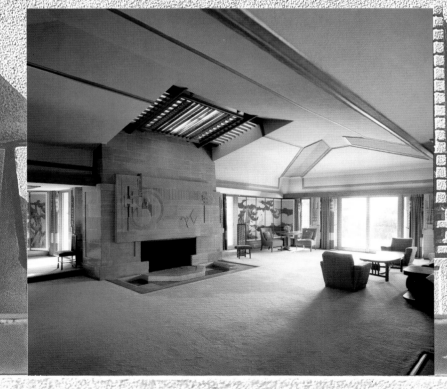

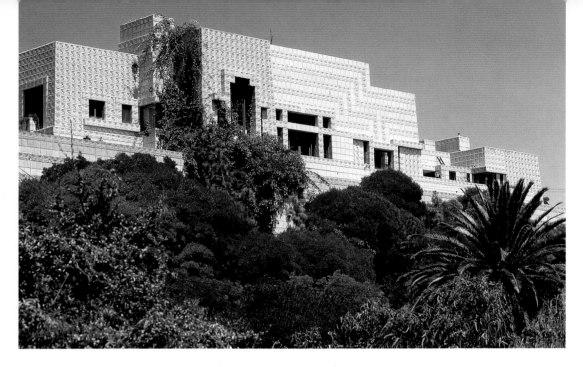

Textile-Block System

Los Angeles experienced a real construction boom after the First World War. Wright's eldest son Lloyd had been operating his own architectural practice there since 1915, and Frank Lloyd Wright also opened an office in Los Angeles in 1923 after his return from Japan. But the commissions he had hoped for did not materialize. Wright only built four concrete houses before returning to Chicago in the beginning of 1925: Millard, Storer, Freeman and Ennis House, all in the greater Los Angeles area, were built in Wright's so-called textile-block system. Two flat pre-cast concrete blocks were connected by steel tie rods and poured concrete to form a steel-enforced concrete cavity wall. The advantage was that concrete was the cheapest material, and you did not need expensive skilled workers to move the stones. Wright found the material, which was generally deemed ugly, ideal for the climate of Southern California: it repels heat in the summer and retains it in the winter. The use of concrete also furthered the development of a totally new aesthetic. The four houses give the impression of monumental, block sculptures, similar to the much larger Hollyhock House. The large wall surfaces are livened up by geometric patterns on the exposed sides of the smaller concrete blocks. The whole wall takes on a nearly textile look due to the placing of the pre-cast blocks.

Ennis House, Los Angeles, California, 1923-1924, front view

Ennis House is the most monumental of these textile-block houses. Facing away from the street, it is supported by powerful walls against the slope and thus dominates the valley like a Maya palace. The rooms are unusually high. Both bedrooms are separated from the living room by terraces, the dining room is elevated by half a story. In Ennis House, Wright worked with leaded glass windows for the last time.

The patterns of the concrete stones create interesting shadow effects on the exterior. On the interior, they constantly create new light effects. But the textile-block system was not destined to succeed. On the one hand, there were faults in the construction, like leaking roofs, and on the other hand, the aesthetics of the textile-block houses radically contradicted the Spanish Colonial Style which was fashionable in California at the time.

Above:
The Maya palace of Palenque, Mexiko, 7-8th century

The four Californian textile-block houses are often called "Maya-houses" because Wright used Native American culture and its world of forms as a source of inspiration without, however, imitating the individual forms.

Storer House, Hollywood, California, 1923, detail of the façade (above), living room (below)

Storer House consists of two wings forming a T-shape. One wing is half a floor below the other. You enter directly into the large dining room, above which the two-story living room is located.

The crossbeam of the T-shape is formed on two floors by two bedrooms each and a terrace on the second floor. Wright's oldest son Lloyd was responsible for the site management in all of the four textile-block houses Wright built in California.

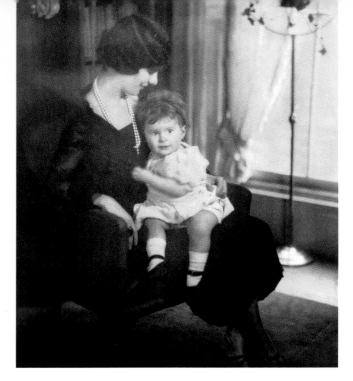

Headlines and Hiding Places

In the mid 1920s, Wright went through the possibly most severe crisis of his life. Everything had looked so good at the beginning: Wright was largely debt-free due to his earnings from Japan and Los Angeles. In late 1922, Catherine finally agreed to the divorce. In the same month in which the divorce was finalized, in November of 1923, he married Miriam Noel at midnight on a bridge across the Wisconsin River. But then two of the most important persons in his life died: His mother Anna died in 1923 and his mentor Louis Sullivan, with whom

Olgivanna and Iovanna Wright, photo, 1927

Frank and Olgivanna's daughter Iovanna was born in 1925, at the height of the mud-slinging which had been started by Wright's second wife Miriam Noel. Only in 1927 could the family return to Taliesin, and Montenegrin Olgivanna had to fear expulsion from the USA until 1930.

he had again become close friends after the rift in 1893, died in 1924. Miriam Noel left him half a year after their wedding, and her psychological instability now took on alarming forms. They agreed on an amicable separation and postponed clarifying the financial situation for the time being. Wright would have to pay dearly for this.

In the end of 1924, Wright met the 26 year old Olga Milanoff Hinzenberg, a cultivated, elegant, beautiful woman. She was the ninth child of a supreme judge and the daughter of a Montenegrin general and war hero. She also was separated from her husband and was waiting for a divorce. Olgivanna, as Wright called her, moved in with him in Taliesin with her seven year old daughter Svetlana in the beginning of 1925. Their daughter Iovanna was born in December. When Miriam Noel found out about Olgivanna, she revoked the divorce and mobilized press and police. In April 1925, a short circuit set fire to Taliesin again. Wright set out energetically to rebuild it for the second time. However, the financial situation was critical. He did plan a cathedral in New York, designed a 32 story high-rise building for the National Life Insurance Company in Chicago and developed a tourist center on Sugar Loaf Mountain in Frederick County, Maryland (see page 42), but none of these projects went past the planning stage. After Catherine and the children had moved out of Oak Park, Wright had to sell his former home.

Noel found an ally in Olgivanna's husband Vlademar Hinzenberg. Together, they deluged Wright among others with adultery charges and reported Olgivanna to the Immigration Service. Wright and Olgivanna escaped, hid with relatives in the country, in Puerto Rico, and near lake Minnetonka in Minnesota, where they were finally hunted down by the police and arrested for a short time. Noel triumphantly moved into Taliesin. The press reported about the issue with daily headlines.

The public opinion soon swung around completely: Wright's first wife Catherine spoke out for him, Hinzenberg got back to his senses, withdrew his charges and broke with Noel.

Noel and Wright were finally divorced in 1927; Wright married Olga in 1928. Miriam Noel moved to Hollywood, from where she kept tyrannizing Wright with phone-calls, letters, and legal charges until her death three years later. As late as 1930, Wright and Olgivanna traveled to Mexico for a short trip, so that Olgivanna could officially apply for immigration to be safe from Noel's charges.

Taliesin, in the meantime, had been confiscated by the bank. Even selling his collection of Japanese art could not pay Wright's debts. For this reason, supporters around Darwin D. Martin founded Frank Lloyd Wright, Inc. in January, 1927. Investing $ 7500 each, the ten partners would receive a share in all of Wright'

future profits. With this shareholder capital, Wright was able to pay off Miriam Noel, secure Taliesin, and repay his debts. Wright returned to Taliesin the same year. He married Olgivanna Hinzenberg in 1928.

In 1929, Wright was not mentioned in Who is Who in America for the first time. His career seemed to have ended when he was 60 years old.

Design for the building of the National Life Insurance Company, Chicago, Illinois, 1924

Wright designed several visionary projects in the 1920s, among them this 32 story high-rise building in Chicago, called St. Marks-in-the-Bouwerie

The Comeback

1929-1935

Wright's life quieted down around the end of the 1920s. He lived two winters in the desert of Arizona with his new wife Olgivanna and worked as a consultant for Albert McArthur, the architect of the Phoenix Biltmore Hotel, and designed the Hotel San-Marcos-in-the-Desert. But the project came to nothing because of the stock market crash in 1929. He published articles in magazines and professional publications and finished *An Autobiography*, which he had started several years before. It was published in 1932. In *The Disappearing City* he developed the social utopia Usonia with the ideal Broadacre City. Wright was "rediscovered" by architects and architectural critics and was also represented at the pioneering exhibition "International Style" in New York, 1932. Also in 1932, he founded the Taliesin Fellowship as a school for architects. However, he was only able to realize a sole building until 1934: an unusually large home for his cousin Richard Lloyd Jones.

The stock market crash in 1929

Frank Lloyd Wright in 1928

1929 At the New York Stock Exchange, the share prices take a dramatic plunge which triggers a global economical crisis. In Hollywood, the Oscars are awarded for the first time.

1930 Frozen food is offered for the first time in the USA and meets a huge demand.

1932 The architectural exhibition "International Style" opens in the Museum of Modern Art in New York.

1933 Franklin D. Roosevelt becomes the 32nd president of the USA. The National-Socialists seize power in Germany

1928-1929 Wright works on the Biltmore Hotel and the resort hotel San-Marcos-in-the-Desert in the desert of Arizona.

1932 Wright's *An Autobiography* and his utopia *The Disappearing City* are published. Wright is also represented at the New York exhibition "International Style". He founds the Taliesin Fellowship as a comprehensive school for architects.

1934-1935 Wright and his students work on the model of his ideal city Broadacre City.

Opposite:
Music hour with the apprentices of the Taliesin Fellowship and their relatives, photo, undated

Right:
Plate at the entrance of Taliesin, Spring Green, Wisconsin, 1911, reconstructed after a fire in 1925

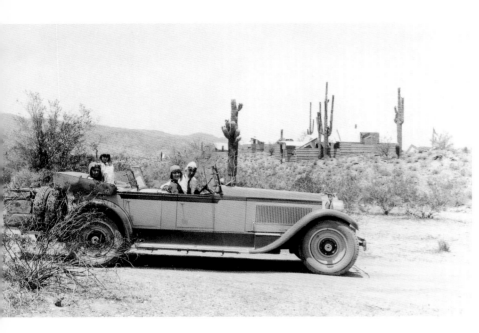

How ever bad his financial situation was – a fast car for him belonged to the basics of a good life, even in the desert. In Ocatillo Dersert Camp, he worked on the drafts for the hotel project San-Marcos-in-the-Desert for four months. The triangular floor plans of the individual parts of the building were inspired by the flowers of the Ocatillo cactus that grows in this area. The rooms were made of canvas and wood and the floors were covered with Navajo carpets. A grand piano stood in Wright's living room.

New Perspectives

Since 1924, Wright had only built a small summer retreat for his most important sponsor Darwin D. Martin. Therefore, he appreciated the offer of a former employee in 1929: He was to act as a consultant for Albert McArthur in the construction of the Phoenix Biltmore Hotel. The extent of Wright's actual share in this textile-block building is unknown. The four months in the desert, however, were a formative experience. Already in 1924, Wright had designed a project for Death Valley and had developed a draft for a house of his own in the desert. In Phoenix, he met Alexander Chandler, who commissioned him to build a hotel called San-Marcos-in-the-Desert. In January 1929,

Wright moved to Arizona with his family and six draftsmen. He put up a temporary residence of wood and canvas called Ocatillo Desert Camp near the construction site. San-Marcos-in-the-Desert was to be built with pre-cast concrete blocks like Wright's Californian houses. The vertically grooved stones, however, should become part of a large pattern covering the whole building. Three stories were planned, erected in terraces on a hill. But the stock market crash in October of 1929 shattered the project just as the commission for the 23 story high-rise building St. Mark's-in-the-Bouwerie. A house for his cousin Richard Lloyd Jones should in the end become the only project that Wright was able to realize in this period. Wright Inc. went

Cover of the first edition of Frank Lloyd Wright's *An Autobiography*, 1932

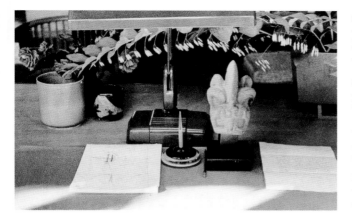

Wright's desk,
photo

Lloyd Jones House, Tulsa, Oklahoma, 1929, front view

Westhope, the unusually large residence for his cousin Richard Lloyd Jones was Wright's only building between 1929 and 1934.

bankrupt after long disputes, because Wright did take out his salary but refused to deposit his receipts. Wright did attempt to mobilize his supporters again, but this time without success.

Once more, he was in a desperate financial situation, and new commissions were not in sight. But the reports of the tabloids had also regained him the attention of the architectural world. Articles were published about him, and he was invited to write essays and review books. He published more than 30 articles between 1928 and 1935 in newspapers and journals. In 1930, Wright gave the renowned lectures Modern Architecture: Being the *Kahn Lectures* for 1930 at Princeton, which were published in book form the following year. Further invitations followed, and for some years, lectures became one of the main sources of income for Wright. A traveling exhibition was devoted to his work, *Time Magazine* and the *New Yorker* published portraits. Inspired by Sullivan's *Autobiography of an Idea*, whose publication he had supported in 1924 and whose style he took up in many instances, Wright started to write his autobiography already around 1926. It was published in 1932 under the title *An Autobiography*.

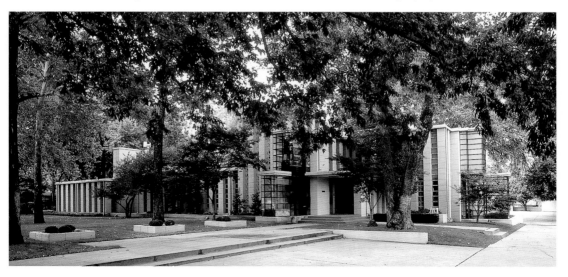

International Style

In February 1932, the International Style Exhibition on modern architecture opened in the new Museum of Modern Art in New York. The curators Alfred H. Barr, Henry-Russell Hitchcock and Philip Johnson named it "International Style," thus getting a terminological grip on the developments of the radically new architecture that had developed mostly in Europe since the First World War. The works of approximately 50 architects were represented in New York, among them Le Corbusier, Ludwig Mies van der Rohe, and Walter Gropius. As a historical predecessor, Wright had also been invited. He accepted the invitation although he was an opponent of the new European architecture and had accused the works of

the young avant-garde of having no soul.

The curators had determined three criteria for the International Style: Firstly, they no longer defined architecture as a voluminous body of a building but as the enclosed space that is limited by smooth, disembodied surfaces made of steel, concrete, or glass. Secondly, they rejected the symmetry around a middle axis and instead demanded that the façade be structured regularly by modules in certain intervals. Thirdly, any ornamentation was scorned at.

Wright's work after 1909 did not fit into the system at all, and so he felt pushed into an unpleasant role by this "rediscovery" in the 1930s. Instead of the lonely, unrecognized ingenious

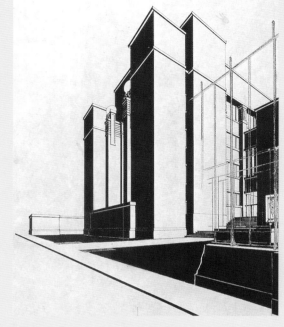

Above:
Larkin Company Administration Building, Buffalo, New York,
perspective drawing from the early 1930s

Erich Mendelsohn Cantata 8 (probably alternative design for the Schocken department store, Nuremberg, Germany), 1926, perspective drawing

pioneer at the vanguard of progress that he felt like, he was presented as a recognized, but historical figure, which was said to have been overtaken by the younger generation. In this context, Henry-Russell Hitchcock even called him the greatest architect and maybe even the greatest American of the early 20th century – but only of the early 20th century. This position posed an enormous challenge for Wright, and he was not short of an answer: "I warn Henry-Russell Hitchcock right here and now that, having a good start, not only do I intend to be the greatest architect who has yet lived, but the greatest who will ever live." A certain influence of the younger architects on Wright since the end of the 1920s is obvious in spite of all differences. The famous sepia drawing of the Larkin Building reminds of the drawings of the German architect Erich Mendelson from the 1920s, and not vice versa. The Johnson Administration Building (see page 74), which Wright designed in 1936, also reminds of Mendelsohn with its horizontal lines. The German architect had visited Wright in Taliesin in 1924 and stayed a few weeks. Wright's Fallingwater House from 1936 (see page 70) goes without ornamentation, like the buildings of the International Style. There is no doubt about the fact, however, that

I believe Le Corbusier and the group around him are extremely useful. Extremely valuable, especially as an enemy.

Frank Lloyd Wright, 1931

Wright did not copy the style of the younger architects but took it up as an inspiration to develop his own style. For example, Fallingwater is already anticipated in Wright's Gale House from 1909 (see page 41) and, upon closer examination, differs very much from the buildings of the International Style. While Mies van der Rohe and Le Corbusier, for example, strictly separated the interior and the exterior, the building and nature, Wright created uniques for each construction site, which, in the choice of form and material, were embedded in their natural surroundings.

Above:
Walter Gropius Gropius House, Dessau, Germany, 1925-26, view from the garden

Frank Lloyd Wright (left) and Ludwig Mies van der Rohe (right) visit the construction site for Wright's Johnson Administration Building, photo, around 1938

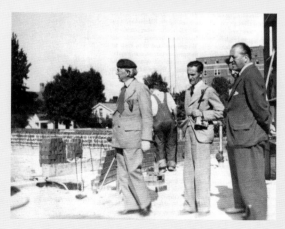

The Fellowship

When the Hillside Home School of his two aunts had to close down, Wright was inspired to found a successor organization. It would be modeled after the Bauhaus, the famous art university founded by Walter Gropius, or after the Cranbrook Academy of Art initiated by the architect Eliel Saarinen in 1924 in Bloomfield Hills, Michigan.

Taliesin, Spring Green, Wisconsin, 1911, panoramic view after the reconstruction of 1925.

Taliesin burnt down twice. It was rebuilt and enlarged considerably each time.

Wright among his students of the Taliesin Fellowship, photo, 1937

In 1931, when Wright was again high in debts, the Taliesin Fellowship was actually founded. 20-30 students should come to Taliesin in order to live and work there. Every apprentice was to pay $650 a year for room and board. This way, Wright did not only provide himself with a source of income but also with free and enthusiastic collaborators and not least an extended family for which he could act as the patriarch. The soul and secret boss of the project, however, was his wife Olgivanna. The opening was celebrated in October, 1932 with 23 apprentices. They shared the facility like they would a large apartment or flat: Wright continued to live in Taliesin with his family while the apprentices lived in the remodeled Hillside Home School, but the headmaster came down every day to spend the day with his students. The scope of the learning objectives was much larger than in a traditional architect's school.

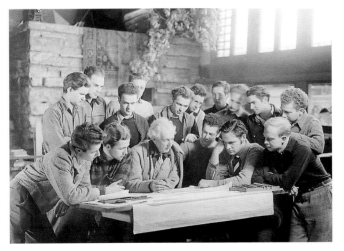

The apprentices were to be educated holistically by an active life in nature. The central idea was: "Learning by doing." The fellows worked with architectural drawings and models, learned artisan skills like working with glass and fabric. They worked on the farm – Taliesin was to be self-sufficient – but were also asked to do all kinds of chores – even babysitting. Wright himself noted apprenticeship was "much like it was in feudal times: ... an apprentice then was his master's slave; at Taliesin he is his master's comrade."

With the fellowship, Wright had created a reliable group of diligent and in some cases very talented collaborators. Without them, he would never have been able to deal with his enormous work load. It is revealing, however, that no really important architect came from the Taliesin Fellowship. The apprentices had to present one of their own

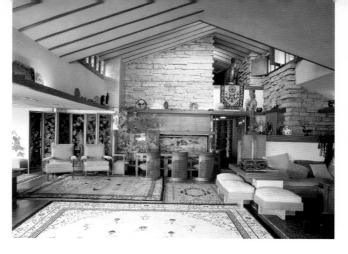

Taliesin
Wright's private living room (above), drafting room for the Fellowship (below)

A kind of campus emerged near the old Hillside Home School, only a short walk down the hill from Taliesin. The school building, which Wright had already built in 1902, was remodeled

for the apprentices. A large drafting room was added. The construction took until 1939. Wright called the drafting room an abstract forest due to the prominent rafters of the construction. A theater was added in 1952. In Taliesin, there was always construction going on in one place whereas in another something else

fell into disrepair. Wright himself said: "No organic building may ever be 'finished'. The complete goal ... is never reached. Nor need be. What worthwhile ideal is ever reached?

projects twice a year, on Christmas and on Wright's birthday. The rest of the time, they worked on Wright's projects. The apprentices were encouraged to find their own architectural jargon and language patterns, but when they became too good, Wright felt threatened; architectural or personal independence was not tolerated for long. If the designs looked too much like those of Wright, they were criticized for being imitations. If they were too individual, Wright also rejected them.

Visions of an Ideal City: Broadacre City

With the book *The Disappearing City* from 1932, Wright created a great utopian vision for city planning and society. He wrote only about the utopian state Usonia (derived from USA) and an ideal city called Broadacre City, but he did understand his model as a suggestion for the reconstruction of America after the stock market crash in 1929. Broadacre was not only a counter-concept to the existing metropolis, which Wright had already pronounced "inhuman" in his lecture *The Art and Craft of the Machine* in 1901. It was also a counter-concept to the radiant city of the Swiss architect Le Corbusier who had designed a strictly geometrical city plan which spread out from a city center with high-rise buildings. For Wright, the individual, not the collective came first. And since, in his eyes, life in the city promotes autocracy and repression, alienates human beings, and turns them into slaves of the machines, Wright designed an anti-city. Every inhabitant should get an acre of land to farm and live on. This way, everyone could have lived in privacy and harmony with nature, in a state of true democracy: "Organic architecture is the Architecture of Democracy," Wright wrote. Broadacre City was designed as a settlement without center.

It was designed to be a modern Garden of Eden

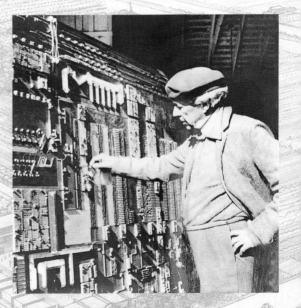

Above:
Frank Lloyd Wright working on his model of Broadacre City
photo, 1934

Opposite:
Perspective drawing of Broadacre City with futuristic flying objects,
1958

for a society that could live leisurely and pleasurably. The concept would become realizable with new technologies, individual transportation like cars or visionary flying vehicles. The greatest experts were to be the father figures at Broadacre's university. The masters of the arts should further develop their abilities in "Style Centers," a combination of artist's colony and research and development center, and pass on their knowledge to select students. There would be only one, universal worship center. The task of the politicians would be to administrate and coordinate rather than to act as lobbyists for interest groups or political parties. Promotion of decision makers from one level to the next should be according to their merits and talents. But an architect should function as the mayor of the city, since "the law-giver and reformer of social customs must have ... the artist's soul." By land ownership, every citizen would become an organic capitalist: There would be no more landlord-tenant relationships. Wright did not object to property and entrepreneurship. He wanted a land without class differences and prejudices, with absolute freedom and unlimited opportunities, with individual settlements and individual family houses. Wright developed the so-called Usonian house as the smallest type of house. He realized it in 1936 with Jacobs House. After the foundation of the Taliesin Fellowship in 1932, Wright built a twelve-by-twelve-feet city model integrating former individual designs from the 1920s like the Gordon Strong Automobile Objective and the high-rise project St. Mark's-in-the-Bouwerie. It went on tour to Madison, Pittsburgh, Washington, and New York in 1935 as a highly noticed traveling exhibition.

Wright continued to develop his visionary city planning for the rest of his life and expressed the ideas in a total of six books. They became the basis for all his later plans and designs. Broadacre City remained a Utopia, but many details later became reality: highway belts around the city, underground parking garages, pedestrian zones, and suburban shopping and professional centers.

Second Bloom 1935-1943

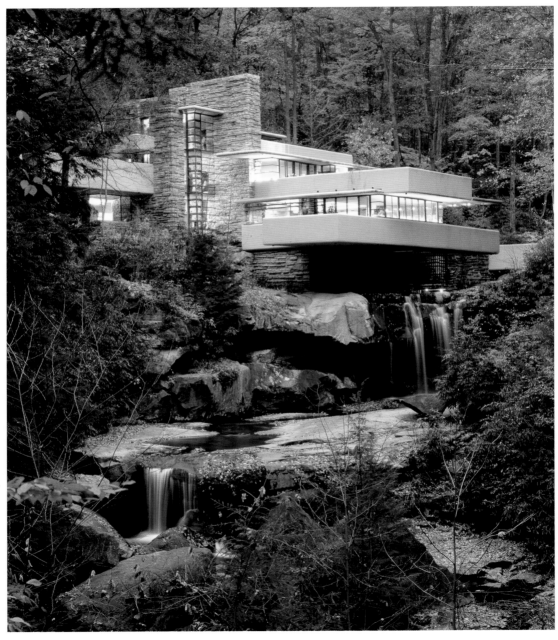

Wright had returned to public attention with publication, lectures, and participation in exhibitions. Finally, he was again commissioned to build houses, and some of his most important buildings were erected within a few years. He designed the weekend retreat Fallingwater, which appeared on the front pages of important magazines and later advanced to be the most famous residence of the 20th century. Only a little later, he built the new headquarters for the S.C. Johnson Wax Company in Racine, Wisconsin. The streamline brick complex became as famous as the Research Tower which was built later. With Jacobs House in Madison, Wisconsin, the first true Usonian house is realized. This type of low-budget house strongly influenced American architecture up to the 1960s. Wright built solid winter quarters for himself and his Fellowship in the desert of Arizona, which he called Taliesin West.

Japanese bombing of Pearl Harbour

Frank Lloyd Wright in Taliesin, 1946

1937 Roosevelt abandons the isolation politics of the USA and declares to take action against "aggressive states." Thereby, the USA abandon their neutral status.

1939 The Second World War starts with the German attack on Poland. Premiere of the movie *Gone with the wind*.

1941 The USA enter the war after the Japanese bombing of the US base Pearl Harbour in the Pacific.

1936 Jacobs House is built in Madison, Wisconsin as the first of the Usonian houses.

1936-1937 Wright builds Fallingwater in the south of Pennsylvania.

1936-1939 Wright builds the headquarters of the Johnson Wax Company in Racine, Wisconsin. The Research Tower is added in 1944.

1937 For the company owner Herbert Johnson, Wright builds Wingspread, his largest residential house ever.

1938 Wright erects solid winter quarters for himself, his family and the Taliesin Fellowship. He calls it Taliesin West.

1939 Establishment of the Frank Lloyd Wright Foundation, to which Wright transfers all of his personal assets.

Opposite:
Fallingwater – Kaufmann House, Mill Run, Pennsylvania, 1936-1937, view from the waterfall

Right:
Desk for the S.C. Johnson & Son Administration Building, Racine, Wisconsin, 1936-1939

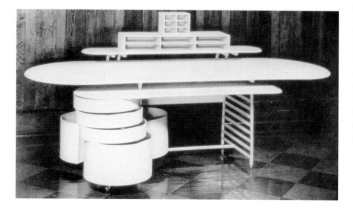

Departure for Usonia

Wright had developed the so-called Usonian house in 1932 for his ideal Broadacre City in the utopian state Usonia as the smallest type of house. The first realized prototype, Willey House, was erected in 1934 in Minneapolis. However, Jacobs House, which Wright built in 1936 for the journalist Herbert Jacobs in Madison, is considered the first truly Usonian house – it only cost $5500.

Wright put up a light one-story wood and brick construction onto a concrete-slab floor. He did without a high roof and a basement to save costs. The garage was replaced by a roofed parking space, which he called "carport." A massive front wall kept out the noise from the street whereas, in contrast, the rear wall consisted of a large glass facade. The house was heated by a radiant floor heating system like the ones Wright had seen in Japan. In the center of the two-winged

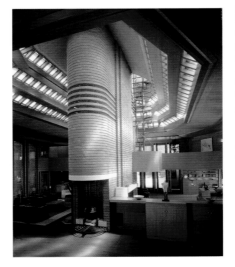

Wingspread, Johnson House, Wind Point, Wisconsin, 1937, air view (above), living room (left)

Wingspread House received its name because, according to Wright, it "spreads its wings." Large terraces and balconies connect it to the surrounding park. The heart of the mill-wheel-shaped facility consists of a high brick-covered chimney with a lookout and four adjoining fireplaces. The high living room is partitioned into different areas by balustrades, seating units, and stairs.

Jacobs House is the kitchen, which Wright from then on would always call the "workspace." Its size is calculated so that all chores can be completed without unnecessary moving around. One wing of the house accommodates the living area with the dining room; this "active living area" is by far the largest room in the house. The bedrooms are in the other wing, most often off a long corridor. The angle between the two wings, which is 90° in the Jacobs House (L-plan structure), always varied in Wright's designs. After the worldwide economic crisis, the low-cost construction method of the Usonian house was an ideal solution for builder-owners of the middle class. Especially journalists and teachers asked Wright to design their houses in the subsequent years. Jacobs House was almost besieged by admirers. The Jacobs family organized tours and took 50 cent per person. When they moved out after a couple of years – again into a new house designed by

Wright – they had made at least the money for the architect's services. Strangely enough, Wingspread, the largest and most luxurious house that Wright ever built, was designed in the same period as this new, small, and moderately priced type of house. Wright called Wingspread his "last Prairie house."

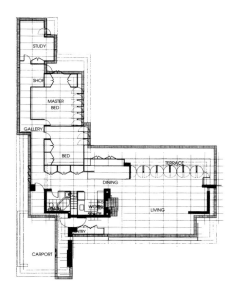

Jacobs House, Madison, Wisconsin, 1936, floor plan

Wright had started using the so-called unit system in the beginning of the century. He aligned the floor plan to a strict grid developed from a rectangular, oftentimes square unit. From the mid 1930s on, this grid was printed on every published floor plan (see page 32).

Jacobs House, view from the garden

The garden views of the Usonian houses with their large windows are oftentimes in strong contrast to the hermetic front façade.

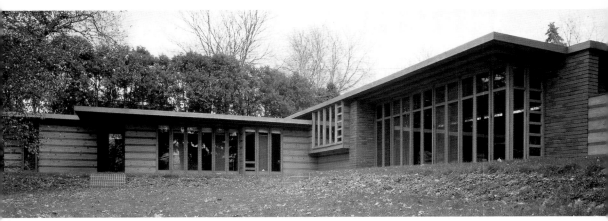

Fallingwater

Fallingwater is considered one of the most important residences of the 20th century. It was erected between 1936 and 1937 as the weekend retreat for the wealthy department store owner Edgar Kaufmann from Pittsburgh. The story of the design, which has been documented by several Taliesin fellows, has become famous.
Kaufmann met Wright in 1934 in Taliesin when he was visiting his son Edgar Junior, who was a Taliesin fellow. He commissioned Wright soon after the visit. A few weeks later he called Wright to inquire about the design. Wright replied that the house was finished, even though not one drawing had been completed. Kaufmann got into his car to drive the 140 miles from Milwaukee to Taliesin. Wright hurried to his studio, laid down three sheets of drawing paper and started to draw the floor plans of three floors with quiet and concentrated strokes explaining his concept to the group of fellows who watched spellbound. After two hours he was done and told two apprentices to draw views from different directions while he himself welcomed the builder-owner, who had just arrived.
Fallingwater should originally have cost 20,000 to 30,000 dollars; in the end, the total costs including the guest house built in 1938 amounted to 145,000 dollars. Fallingwater is built in a low mountain range in south Pennsylvania above a small waterfall. Legend has it that Kaufmann originally wanted to build his house further up but Wright asked him: "You love this waterfall, don't you? Then why build your house miles away, so you will have to walk to it?" The verticals, the supporting walls, are made of gray, unfinished limestone, the horizontal cantilevers are cast in concrete. Wright originally wanted to cover the concrete with gold leaf or with a thin layer of aluminum, but Kaufmann rejected both suggestions. In the end, they decided for a warm ochre tone.
The large living room and the kitchen are situated on the ground floor, two bedrooms and a small guest room on the second floor,

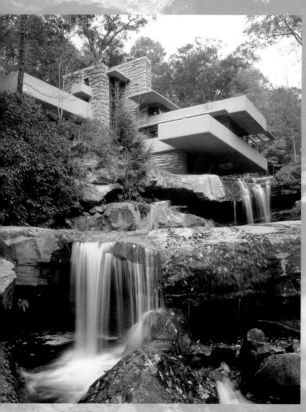

Fallingwater, Kaufmann House, Mill Run, Pennsylvania, 1936-1937, view from the waterfall (left), view from the mountain (opposite, top), living room with fireplace and seating unit (opposite)

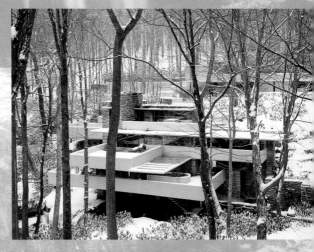

and the rooms for the son of the family are on the top floor. Each floor recedes into the mountain, the terrace of each floor is the ceiling for the rooms below it. The house protrudes over the waterfall which cannot be seen from the house. However, a staircase leads directly from the living room on the ground floor to the stream. Fallingwater is exclusively designed with rectangles. The different living areas in the living room are placed in different zones of the room: a library, a dining area near the kitchen, seating near the open fireplace, and a further suite between the two terraces. The walls are made of ashlar on the inside, the ceilings are plastered, and the floor is made of shining polished stone. Only in front of the fireplace, a large unfinished rock springs out from the floor. The view from below is famous and has often been printed and written about. The house seems to hover over the waterfall. From above though, the terracing of the house appears quite natural. In abstaining from ornamentation, with the open floor plan on the ground floor, and the precast concrete horizontals, Fallingwater reminds of the designs of the International Style. However, Wright's balcony railings are curved, volumed, and possess cubic force, whereas the surfaces of the avant-garde buildings seem like outstretched canvases. The buildings of Mies van der Rohe and Le Corbusier often ignore their surroundings, while Fallingwater self-confidently integrates into the landscape.

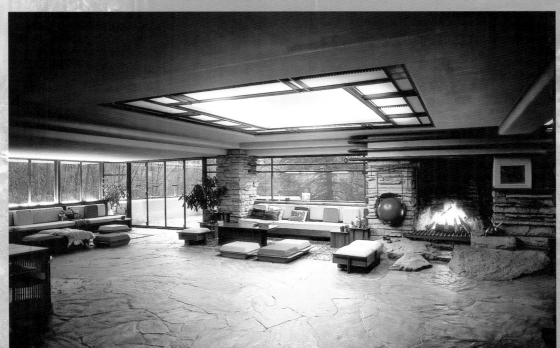

Life in the Desert: Taliesin West

In the 1930s, Wright's physician recommended him to spend the winter months in a warmer climate. This was seminal for the idea of a solid winter residence. After a long search, Wright finally bought a suitable piece of land north-east of Phoenix, Arizona in late 1937. Ever since a project for Death Valley in 1924, Wright had been fasci-

describes his life and the projects in the desert, bears the title "Freedom." The desert for him was a place of renewal and independence. Here, he felt the immediate contact to the elements.

In January of 1938, the fellows erected the winter quarters Taliesin West in the desert of Arizona. Little by little, the wood and canvas construction was replaced by solid buildings. For the walls, fieldstones were bound with cement, the superstructure was built with pine-

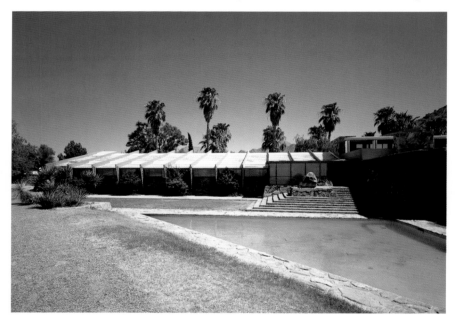

Taliesin West, Scottsdale, Arizona, 1938, outside view with swimming pool

In choosing his construction materials, Wright adapted to the unusual site in the middle of the desert. For the walls, fieldstones were cast in cement in a such a way that the rough surface of the dispersed stones remained visible. Wright called these seemingly prehistoric walls desert masonry. He later used this method in several residential houses. The superstructure was made of pinewood and canvas. The light entered the rooms through the canvas like a warm glimmer. Around the building, Wright placed stepped terraces, ponds, and gardens to create a veritable oasis. In contrast to Taliesin North, as the complex in Wisconsin was now called, Wright's workplace was in the middle of the encampment. He often appeared unexpectedly in the large draftroom in order to inspect the works of his apprentices or add a touch himself.

nated by the desert. He had then even drafted a house for himself and his family, which should have been built in the desert. How much the desert meant to Wright becomes clear in his autobiography: The fourth part, in which Wright

wood and canvas. In the course of time, the facility was enlarged to house 60 fellows. 1951 to 1952, a cabaret theater was added, in 1957 a large music pavilion.

Every winter, a large convoy set out from Wisconsin to the south.

formation of Wright's public image. Here he was a pioneer again, who lived far removed from civilization like a chief with his followers instead of having a pleasant life in the green Midwest. After a visit, the architectural critic Hitchcock described the camp as having a nearly prehistoric dignity.

The Taliesin Fellowship still exists today as an architectural practice in Taliesin West. They are supported by the Frank Lloyd Wright Foundation, to which Wright contributed all of his personal assets. The Frank Lloyd Wright Archive today shelters a treasure of 21,000 plans, sketches, and drawings.

The trip by car and truck took several days. There were approximately 30 people on board: apprentices, servants, and the family. The normal daily routine in Taliesin West started with getting up at 6 a.m., breakfast at 7, choir at 8. Working time was from 8.30 to around 5.30 p.m., only interrupted by a lunch-break between 12 and 12.30. The workday ended with dinner at 6.00 p.m. In the evenings there were film showings, lectures, or concerts with discussions afterwards.

Every Saturday, there was a formal dinner. Wright, Olgivanna, and the apprentices often went into the countryside for picknicks. On Sunday, after breakfast, Wright would preach for two hours about architecture and its meaning for society. Taliesin West was decisive for the

Taliesin West
Wright with several students (above), living room (below)

The S.C. Johnson Administration Building

Three decades after the Larkin Building (see page 30), Wright designed another revolutionary headquarter: the Administration Building of the detergent company S.C. Johnson & Son in Racine, Wisconsin. S.C. Johnson & Son was the first company to give their employees a share in the profit in as early as 1917. This social mindset was expressed in Wright's Administration Building that was erected between 1936 and 1939.
The complex has windowless red brick walls and is cut off from the exterior like an industrial building. As with many of Wright's large buildings, the facility has two parts. It consists of a main building with a square floor plan and a covered parking area. The entrance of the main building is at the interior of the lot, between the two buildings. Almost all workplaces are in one single room with 80 thin dendriform pillars. These support the glass roof and, as it were, form a "forest" with their plate-shaped surrounds. Light falls in indirectly through the "treetops." The skylights are assembled from glass tubes of varying diameter. The area where the roof and the walls meet is made of glass tubing, too. This is only possibly because the walls do not have a bearing function. The tubes are lit at night and with their rounded corners create a breathtaking dynamic from the outside.
The management offices are in an attached floor, in two oval penthouses, that again take up about half of the floor area of the building. They can only be reached through the main office workspace. Here again, Wright designed the whole furniture himself. The room is defined by the warm brownish-red of the

Below:
S.C. Johnson & Son Administration Building and Research Tower, Racine, Wisconsin, 1936-1950,

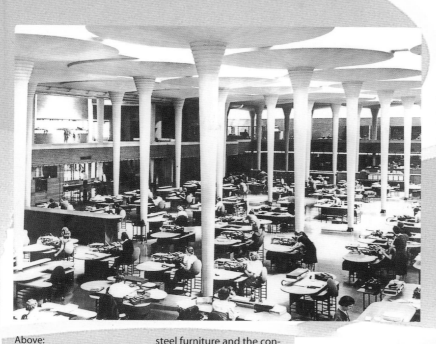

had ordered because they did not believe that the pillars had a bearing capacity of 12 tons (legally prescribed were six times the necessary bearing capacity) turned into a triumph for Wright. In front of the assembled national press, Wright placed himself under a test pillar while a crane heaved ton after ton onto the plate over the pillar. The pillar collapsed at dusk - Wright was at that time watching from a safe distance - under a weight of 60 tons.

Above:
S.C. Johnson & Son Administration Building,
1936-1939,
main office workspace

Right:
Structural analysis test for the S.C. Johnson Administration Building,
photo, 1937

steel furniture and the concrete floor.

Between 1944 and 1950, the Johnson Research Tower was added as a laboratory. This fourteen-story building is supported by a vertical column, a central core from which the floors cantilever like the branches of a tree. They are alternating in shape: one is circular the next square, so that you can look down over a balustrade from the circular onto the square floors. The outside walls are made of brick bands which alternate with walls made from glass tubing. They admit light but cut off the view outside, which might divert the employees from their work. The structural analysis test that the building authorities

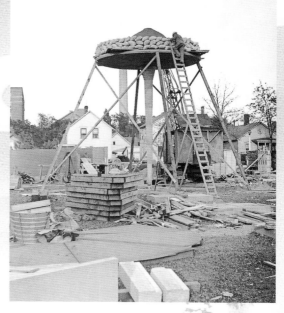

The Doyen

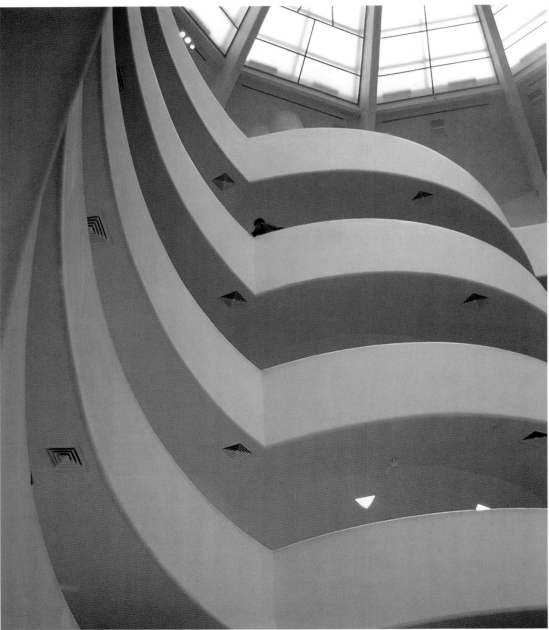

With Fallingwater, the Johnson Administration Building and the Usonian house, Wright became a media celebrity within a few years – as the first architect. Mentally and physically at best health, the "venerable dean of modernism" stayed present in magazines, newspapers, and television broadcasts until the end of his life. After the Second World War, the number of his designs and of his executed buildings reached astonishing dimensions: For residential houses alone, Wright developed 260 designs between 1946 and 1959. Additionally, he worked on several large projects: City planning for Baghdad and Pittsburgh, churches and synagogues, office buildings and – in the last year of his life – his only state commission: a county administration. As early as 1943, he designed a museum for the art collector Solomon R. Guggenheim, which was only started in 1956 in New York. It was completed in 1959. Wright died on April 9, 1959 in Scottsdale, Arizona – half a year before the opening of the museum.

Martin Luther King holding a speech

Frank Lloyd Wright in 1957

1945 After Roosevelt's death, Harry S. Truman becomes president of the USA. Germany surrenders to the allies. American atomic bombs explode over the Japanese cities of Hiroshima and Nagasaki. United Nations are founded.

1947 Beginning of a fierce battle against communism in the USA, which had its peak with the scrupulous activities of Senator McCarthy.

1952 The USA explode their first hydrogen bomb in the Pacific.

1955 Elvis Presley starts his first US-tour.

1956 Lead by Martin Luther King, African Americans achieve the end of segregation in public transportation.

1943 Wright is commissioned to build the Guggenheim Museum in New York.

1948 Wright builds the first large spiral ramp for V. C. Morris Gift Shop in San Francisco.

1949 The construction of the Unitarian Church in Madison is the first of a series of churches that Wright builds for different denominations.

1950 Wright's first design of a house consisting only of circular shapes – Friedman House – is erected.

1952-1956 The only one of Wright's highrise buildings that was realized – the Price Tower – is built in Bartlesville, Oklahoma.

1956-1959 The Guggenheim Museum is finally built.

1959 Wright designs the Marin County Civic Center. He dies April 9, in Scottsdale, Arizona.

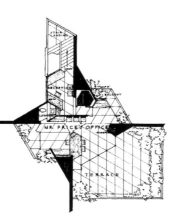

Opposite:
Guggenheim Museum, New York City,
1956-1959,
interior

Right:
Price Tower, Bartlesville, Oklahoma,
1956,
floor plan of the 17th floor

The Celebrated Eccentric

Wright and Olgivanna,
photo, undated

Wright enjoyed living on a grand scale. He dressed in expensive tweed capes and selected ties. He loved to buy clothes and haggle about the price with a wink.

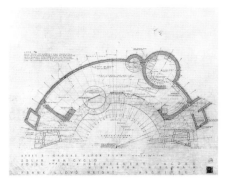

Whereas up to 1930 it had mainly been the tabloids that reported on Wright, the last two and a half decades became a tremendous triumph for him: Fallingwater was the most photographed house in the world. In 1938, *Time Magazine* published a cover story about Wright and Fallingwater, and the Johnson Administration Building was on the front page of *Life*. For *Life*, Wright also developed a Usonian house in the same year which thus became known to a wide audience. The renowned magazine *Architectural Forum* even offered Wright a whole edition, which he could design and write himself. In it, he presented himself as revolu-

tionary pioneer of modern architecture but also as the defendant of the organic ideal, whose principle all modern architects had misunderstood.

Wright cleverly staged himself as the great old man of architecture, who was now traveling the world with his young, attractive wife in order to give lectures and develop projects which became increasingly

Solar Hemicycle: Jacobs' Second House, Middleton, Wisconsin,
1948,
view from the garden (right) and floor plan (top right)

The second house that Wright built for Herbert Jacobs is one of Wright's unusual projects from the 1940s. It has the shape of a hemicycle. A soil mound is banked up to the north, a glass façade opens to the south onto a sunken terrace.

unusual, visionary, not to say: eccentric.

Even at the height of his success, Wright never repeated himself. The only constant in his immense creative work of the last two decades is permanent change, re-creation, variety. His positive commentaries after a trip to Moskow in 1939, his pacifistic position during the war, and his pro Japanese and pro German statements in

Someone is taking a picture of Wright on a walk,
photo, 1957

According to himself, Wright got his best ideas on long walks. He came back with sketches and immediately drew up the central idea at the drawing board.

the beginning of the war earned him sharp criticisms. However, as an artist he enjoyed unlimited authority even though, compared to the dominant International Style, he remained an outsider until the end. He received awards and honorary doctorates from universities and academies all over the world.

In the Nature of Materials, an extensive biography on Wright by Henry-Russell Hitchcock, was published in 1942. Wright had selected the author himself. The bestseller *The Fountainhead* by Ayn Rand also contributed to the legend of Frank Lloyd Wright. Rand describes an architect who unswervingly follows his path. The character of the heroic loner Howard Roark was generally associated with Wright. In 1949, the novel was made into a movie with Gary Cooper in the role of the architect.

Open house in Taliesin North,
photo, 1957

At the open house in 1957, there was a miles long line-up of cars in front of Taliesin North as it was now called. Both Taliesins were nearly swamped with guests and apprentices. In the autumn of 1946, 65 apprentices belonged to Taliesin plus their wives and children. About half of the fellows came from foreign countries.

The Search for a New Geometry

Already in the 1920s, Wright had experimented with unusual floor plans, but he could not realize his visions in these turbulent years. In some of the large projects of the 1940s and 50s, he took up his old ideas and developed them further. And also in the small and medium residential houses that Wright had been building since the mid 1930s, one can find unusually free forms in the floor plans and vertical planes.

Since the beginning of last century, Wright had been using his so-called unit-system for his designs. That is, he drew his floor plans on paper with a grid of small basic units. While these units were rectangular or square during the Prarie house era, Wright now experimented with new forms.

Hanna House (named Honeycomb), built in 1936, is based on a

Wright at the drawing board with a student,
photo, 1957

Llewellyn House, Bethesda, Maryland, 1951, floor plan

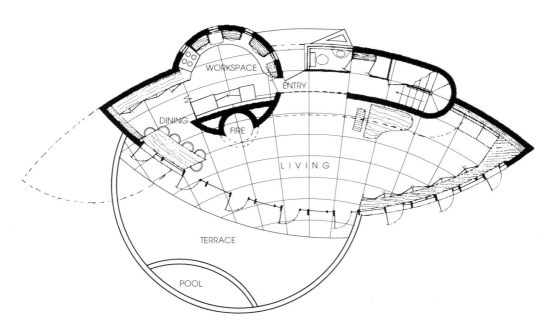

It is possible that Wright took the inspiration for the floor plan of Sol Friedman's house from the first name of the owner-builder, a toy manufacturer. Sol is Latin for sun. The floor plan of the house itself consists of two overlapping cylinders. The larger circle accommodates the living area, the smaller kitchen and bathroom. The bedrooms are located above, on the second floor. The house is situated in the middle of a slightly inclined, forested piece of land. A long stone wall around a large terrace embeds the house into its surroundings. In the same year, Wright designed a house that was developed out of a single large circle for his son David on the edge of the desert in Arizona. The living rooms cover a half circle of the top floor, under which a shaded garden was planted. A large spiral ramp leads up to the house completing the circular shape of the house.

hexagonal unit system, Boomer House, 1953, is based on a diamond. As he had put forward in his 1911 essay The Japanese Print, Wright saw the different basic geometrical shapes as symbols for different ideas. Significantly enough, he constructed two of his late churches, the Unitarian Church in Shorewood Hills, Wisconsin (see page 90) and the Beth Sholom Synagogue in Elkins Park, Pennsylvania (see page 87) on a triangular basis. Triangular shapes for Wright symbolized unity. The design for Jester House dates back to 1938. Its construction is based on interlocking circles of different sizes, for Wright the symbol of eternity. In this, it resembles Friedman House from 1950. The floor plan of Llewellyn

House of 1951 is based on a circle segment. Wright also played with the respective round and oval forms in the furniture, which he most often designed himself.

The spiral form, for Wright symbolizing the "organic process," was first used by him in 1925 in a design for a lookout platform, the Gordon Strong Automobile Objective. He first realized a spiral form in the construction of Morris Gift Shop in San Francisco 1948. The ramp in this small furniture shop spirals up from the first to the second floor. And also the famous Guggenheim Museum in New York is based on a large spiral.

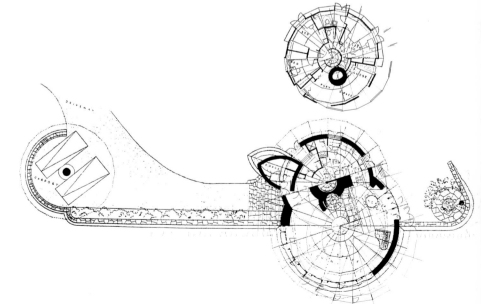

Vision and Reality

It rained and stormed in Racine. Herbert Johnson had just moved into his new Wingspread House and was hosting a large dinner party when suddenly a drop of water hit his bald head. More drops followed at regular intervals – it was raining through the roof. The infuriated Johnson called his architect, but Wright calmly advised him to sit somewhere else. The members of the Beth Sholom Synagogue had to escape to another room in 1960 because of the water leaking through the roof. And the employees of the Johnson Wax Company most often had an empty bucket standing next to their desk, which, nevertheless, did not protect them from the glass tubes that would fall down from the ceiling every once in a while.

There are thousands of stories about leaking roofs. And they did not only oc-cur when Wright had experimented with new materials like in the Greek-Orthodox church in Wauwatosa, Wisconsin, where a large part of the ceiling collapsed after a few years and also the outside of the building had to be newly faced for a lot of money. The reason for this deplorable state of affairs was not that Wright could not design tight roofs – it simply was not important to him. Three formative experiences had demonstrated to Wright that it was the idea that mattered in architecture and not the actual realization. More than "real" architecture, the papermaché sets of the World Fair of 1893 in Chicago had influenced the American architecture of the following decades. And these were only showpieces that were torn down after a year. His own breakthrough Wright did not owe to an executed build-ing but to the two designs published in *Ladies' Home Journal* of 1901. And in Europe he became famous for a collection of prints: the Wasmuth Volumes. Not by executed architecture could he become "the greatest architect of all time" but by his visions, his plans, and impulses for subsequent architects. This was what counted. This attitude also explains why he designed many projects that in the short run did not have a chance of realization, for instance the "Mile High Illinois" tower for Chicago, "The Oasis," a new state capitol for Arizona, or the designs for the utopian Broadacre City. "Form follows function," the maxim of Louis H. Sullivan, was something that Wright would surely not have subscribed to. He was interested in the shape, not in whether the roofs were tight or whether the clients liked living in their houses.

Left:
Design for "Mile High Illinois" tower, Chicago, Illinois, 1956

Right:
Annunciation Greek-Orthodox Church, Wauwatosa, Wisconsin, 1956, front view

Function was only the initiator for his idea. And even when Wright tried to realize his visions as perfectly as possible, he knew that in the end the building could never reach the perfection of the idea. Buildings dilapidate, ideas do not: It was not sufficient for him that his designs were spread, his buildings were photographed. Wright's buildings were not only expensive to build, they were also expensive to keep up. Wright had not considered the wear and tear the buildings would be exposed to over the years. When the floor heating of the first Jacobs House did not work right, the whole floor had to be torn out. Wright simply had forgotten to design an access for repairs –

Above:
Frank Lloyd Wright during an interview in Taliesin, photo, 1957

Design for the Oasis - Arizona State Capitol, Phoenix, Arizona, 1957, perspective drawing of the night view

and this was definitely not a single case. Against all warnings, he placed Millard House in California on a plot where it was likely to be flooded. When the flood came, Wright made excuses saying that this had been the worst flood in fifty years. This is not the answer of a man who builds houses to last. It is not due to the new materials that many of his houses failed in practical usage. Wright used the known technologies to their fullest, always on the lookout for new untrodden paths. In doing so, he took risks; mostly at the expense of his clients. However volatile his life, Wright was consistent in one thing: His striving for innovative architecture knew no compromises. The necessities of daily life to him were only small nuisances.

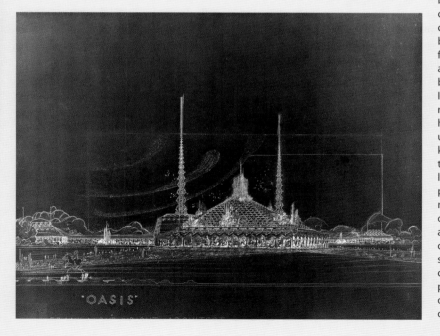

"OASIS"

Late Major Buildings

Although he was an internationally accepted architect in the later years, Wright was only awarded one state commission, because he often behaved in a politically "incorrect" fashion. When he tried to protect his apprentices from the chase of alleged communists in the USA in the beginning of the 1950s, and he openly said so. This is how Wright came to be under close observation of the FBI again in 1954, at the peak of the so-called McCarthyism. Years later, when he presented the design for the Administration Building of Marin County, California, a file turned up, in which Wright was accused of com-

Administration Building and Hall of Justice of Marin County, San Rafael, California,
1959-70, outside view

Like arches of a bridge, the administration wing and the longer Hall of Justice wing stretch out between three hills. The offices are placed on three

draft during the Second World War by claiming to need them for farm labor, Edgar Hoover, the FBI chief at the time, was said to have personally ordered an investigation. Yet, Wright never said anything antidemocratic or communist.

His highest ideal, which he defended vehemently, was the freedom of the individual. He despised Senator Joseph McCarthy and his munist activities. But the clients were not impressed by it, and Wright was awarded the only government commission of his career. In the mid 1950s, Wright could also build his only high-rise building: Price Tower in Bartlesville, Oklahoma. For this design, he took up a project of the 1920s, the high-rise building St. Marks-in-the-Bouwerie, which had not been realized.

single-story arcades on both sides of an open atrium that runs through the whole building. The domed library forms the joint and is the dominating part of the construction. A radio antenna rises beside it. Wright was able to finish the plans shortly before his death.

Since Wright thought that high-rise buildings were "unnatural," he followed the system of a tree: supporting beams start from the supply center in the middle – like a tree trunk.

Even though Wright turned to large and visionary projects, building residential houses remained the most important task area in his practice. Between 1946 to 1959, Wright designed the incredible number of 260 residential houses; in 1950 – Wright was 80 – he planned and built 21 houses. This enormous productivity was only possible with the help of his fellows, who most often took over the supervision on the site.

The master plan for the Florida Southern College most closely resembles the concept of the city plan for his spacious ideal Broadacre City. He designed 18 buildings for the university of 800 students. But until Wright's death in 1959, only seven could be realized due to the university's small financial means.

Price Tower, Bartlesville, Oklahoma,
1956, outside view

The floor plan is formed by two squares which are turned against one another. It is separated into four identical parts. The supply systems are located in a core in the middle of the building. Three quarters of the space accommodate offices, the last quarter offers room for two-story apartments. The silhouette of the tower is especially dynamic due to the staggering of the top floors. The floor plan (see page 77) shows the 17th floor, on which only a quarter of the ground floor space is used.

The 1950s

On his 80th birthday, Wright declared that his creativity had kept him young. Work was his elixir of life, he did not cease to emphasize this. It stimulated his spirit, his imagination, and his talents. And, in fact, Wright remained in good shape in body and mind up to his 92nd year.

In the 1940s at the latest, Wright became a US celebrity like otherwise only athletes, singers or actors. Articles on him and by him appeared regularly in magazines like *Time* and *Life* or the *New York Times*. He enjoyed presenting himself. In talk-shows, to which he was often invited, he usually seized control. Asked or not, he gave his opinion on every possible subject, and his commentaries were increasingly caustic. About his fellow architects, for instance, he said that he admired them, but that he did not have the same feeling for their works.

Wright was spirited and tremendously charming. What distinguished him above all was his ability to inspire people. He kept a nearly childish playfulness until his old age, an enthusiasm for his creations that no one could resist. His son, John, described how Wright would paint the picture of the house of his clients in shining colors.

"About all my clients have testified to the joy and satisfaction they get from their own particular

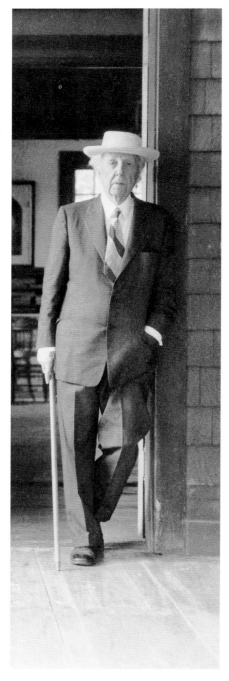

Frank Lloyd Wright at the entrance of the small family chapel in Taliesin North, photo, 1957

Wright impressed people with his snow-white hair and his tanned face as well as with his expensive and exquisite wardrobe. He always carried an elegant walking stick. A younger relative recalls that he was very vain: when they talked and there was a mirror in the room, Wright would look at the mirror more than at him. Wright never developed a "healthy" relationship to money. His son John remembers that Wright carried around bills crumpled in his pockets – in his pants, vest, jacket or coat, and he never counted his change. He could always count on rich sponsors, especially on Darwin D. Martin and Edgar Kaufmann. With some people, however, Wright pushed his luck too far and the relationship was ended.

building," Wright was pleased to say. In spite of the enormous productivity of his practice, Wright continued to be in permanent financial difficulties until the end. But he always found sponsors who enduringly financed his luxurious lifestyle, not without – useless – admonitions for betterment. He did not to the least think of adapting his expenses to his income: During the last years of his life, when the Guggenheim Museum was built, he rented a suite at the New York Plaza Hotel which he redecorated completely. He resided there for four years, with a view of the Central Park.

The end came suddenly. Wright was hospitalized in Scottsdale, Arizona with a fever on April 4. He died five days later on April 9, 1959, only two weeks after his first wife Catherine, whose death is said to have affected him very much.

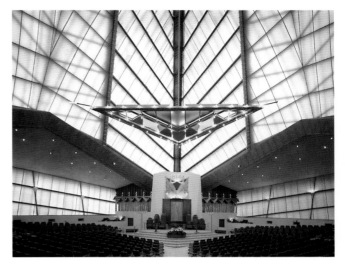

Beth Sholom Synagogue, Elkins Park, Pennsylvania, 1959,
prayer hall (above), outside view (right)

One of the most important buildings of the 50s is this synagogue seating 1000 people. Wright took up a design from the 1920s that had not been realized at the time. An inverted hexagonal fiber-glass cone was perched onto a triangular base of poured concrete. Together, this formed an abstract Star of David, but it also reminded of the nomad tents of the ancient Israelites. Wright thought of the building as a metaphor of Mount Sinai, the place where Moses received the ten commandments.

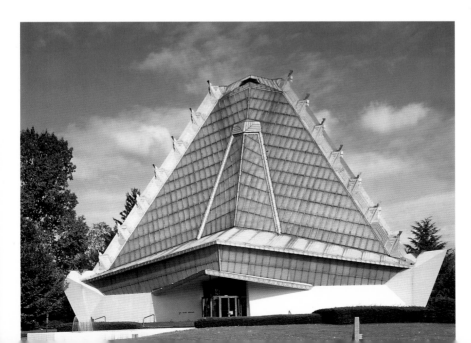

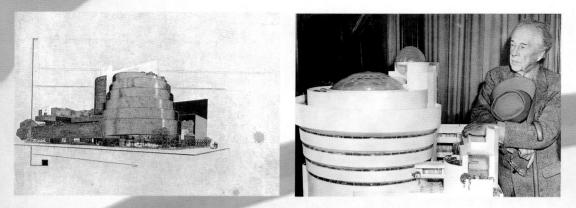

The Guggenheim Museum

Strangely enough, Wright's most famous building is a museum for modern art of all things. For he did not tolerate any pictures in his buildings except Japanese prints. He did not like modern paintings, and the effect of his architecture was more important to him than any art collection. In fact, the architecture does dominate the exhibits in the Guggenheim Museum. Solomon R. Guggenheim, then one of the richest men in America, wanted to exhibit his significant collection of nonobjective modern art permanently. The contact between him and Wright was established in 1943. Wright presented the first designs in 1944 and in 1945, the model was presented to the public. But eleven years should pass before the start of the construction. In-between, there were changes of location, trouble with the construction supervision, and several changes in the management of the museum – Guggenheim himself died in 1949. When Wright died in 1959, the museum was essentially finished. It was opened in October 1959. Matching the "revolutionary" art of his collection, his museum was to be a new type of building, which would invite the visitors to experience the pictures in a new way. "I'm trying to make

Guggenheim Museum, New York, 1956-1959

Early design from 1944 (top left), Frank Lloyd Wright with the finished model (above), birds-eye view of the museum with the addition in front of the New York Skyline (bottom left), outside view of the exhibition building (below).

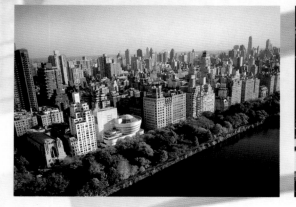

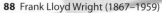

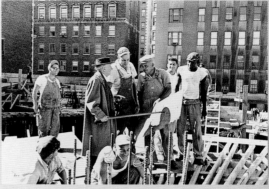

Guggenheim Museum, New York,
1956-59,

Birds-eye view of the construction site in 1958 (above), Frank Lloyd Wright inspecting the construction work in 1957 (top right), perspective view of the interior with visitors (below), interior with exhibits (bottom right)

a building where seeing works of art would be so natural," Wright explained. The Guggenheim Museum consists of two spirals cast in concrete, a large one for the exhibition and a smaller one in front for the offices of the museum management. The entrance is situated between them.
Inside the museum, the visitor takes an elevator upstairs and then walks down a narrowing spiral ramp of five full revolutions. The ramp opens to an atrium. It is not a substitute for a staircase but it is the exhibi-

tion space itself. This makes it possible to display the collection of the museum or the artistic development of the work of an artist without having to divide the works thematically or chronologically into separate rooms.
The room is lit by a large skylight dome in the atrium and by glass slits between the spiral walls. The walls are slightly inclined to the outside to make possible a more "natural" placement of the pictures, like on an easel. Wright's goal was to "make the building and the

painting an uninterrupted, beautiful symphony such as never existed in the World of Art before." But the museum management and some prominent artists protested vehemently, and just after Wright's death, changes were made in the concept of hanging the pictures. There was also a heavy dispute about the color of the walls, because Wright rejected white as the "loudest" color. However, Wright died before the issue could be resolved unanimously, and the walls were painted white.

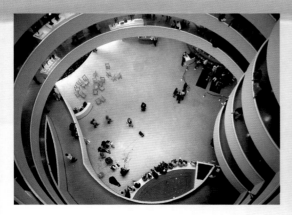
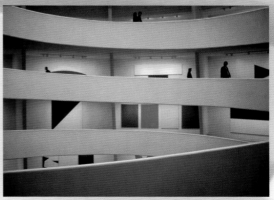

What's the Wright Way?

No architect can put something on paper today without unconsciously paying tribute to Frank Lloyd Wright.

Taliesin-Fellow Edward D. Stone, *A Tribute to a Personal Hero*, 1960

Frank Lloyd Wright's work cannot be subsumed under one heading. At most, there are certain characteristics, which are valid for individual periods of his work. His overall work, which spreads out over 70 years and which comprises more than 450 executed buildings and uncountable projects, designs, and theoretical writings, is more diverse and ambiguous than the works of any architect of the 20th century. Nevertheless, Wright's creativity was rooted in strict principles: those of "organic architecture", which he continued to swear by in his lectures and writings. He saw his task as an artist as having to abstract the shapes of nature and to display them in their "truer" form. Nature for him was the expression of "divine beauty." And as nature always displays an infinite diversity, Wright also never

Unitarian Church, Shorewood Hills, Wisconsin, 1947, silhouette of the roof

Left:
Willits House, Highland Park, Illinois, 1902, dining room

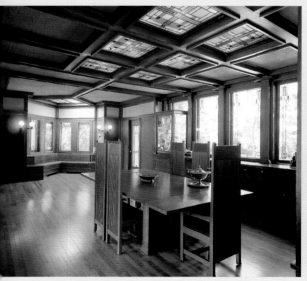

Below:
Model for Wright's ideal city Broadacre in the utopian state Usonia, 1934

ceased to search for unusual shapes and materials. Playing with the Froebel educational blocks as a child was formative for Wright: they had instilled in him a sense for geometrical shapes. Especially the late work of Wright is determined by unusual floor plans. The vertical planes often correspond to the floor plan: For example, a triangular roof that rises over the triangular floor plan of the Unitarian Church in Shorewood Hills, Wisconsin. Wright always experimented with new materials. He was, for instance, one of the first architects who had a whole house cast in concrete: Unity Temple in Oak Park, Illinois. Even though his most famous building is a museum, the Guggenheim Museum in New York, and he was often able to realize important large commissions –Unity Temple, the Larkin Building, the Imperial Hotel in Japan – the real domain in his lifetime were residential houses. He developed an independent type of house, the Prairie house, between 1901 and 1909. It is defined by the

emphasis on the horizontal line, parts of the building protruding into the surroundings, and the break-up of the room separations on the inside. With this type of house, Wright became a model for the young European architects, which later

represented the avant-garde of modernity. In the mid 1930s he designed the Usonian house, the smallest unit for his great vision for city planning: Broadacre City. It was a type of house for builder-owners with a low budget. It should

pioneer the development of the American architecture of the following decades. With a total number of 17, more buildings by Wright than by any other architect are under protection as a National Heritage in the USA.

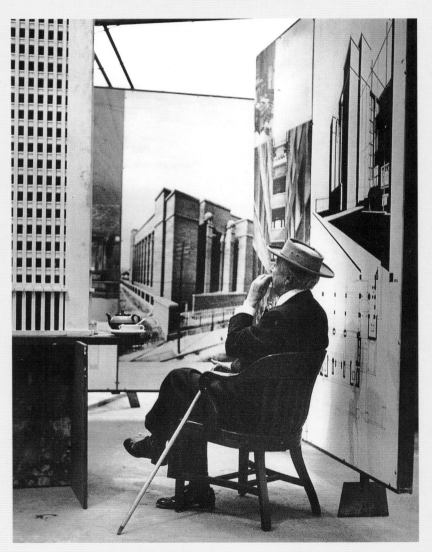

Frank Lloyd Wright at the 1953 New York Exhibition "Frank Lloyd Wright – Sixty Years of Living Architecture"

The architect pauses in front of the photo walls of his Larkin Building of 1903 which had been torn down in 1950.

What's the Wright Way? **91**

Glossary

Arts and Crafts Movement Informal reform movement in architecture and the decorative arts, named after the Arts and Crafts Exhibition Society founded in London in 1888. Based on the theory of the British artisan William Morris, it championed a unity of the arts, the experience of the individual craftsman, and the qualities of materials and construction in the work itself. A socially concerned countermovement to industrial mass production, it favored traditional simplicity, working in wood, metal, enamel, and glass. The Chicago Society of Arts and Crafts was founded in 1897. The A. influenced architects in the choice of materials, creation of a regional style echoing the horizontals of the prairies, and their interest in designing furniture, in metalwork, and in the decorative details of the interiors.

Atrium (Latin: Courtyard) Originally the name for the courtyard of a Roman home, around which the other rooms were located. Today describes a large, open space inside a building, which often extends over several floors usually for representative purposes.

Avant-garde (French: vanguard) Group of pioneers which is committed to the advancement of new artistic ideas and ideals. The avant-garde of the early 20th century, a reaction against the established art with its bourgeois traditions, challenged the function of art in the face of politics and daily life.

Bauhaus School of art, design, and architecture founded in 1919 by the German architect Walter Gropius. The school re-established workshop training as opposed to academic studio education. It influenced the development of functionalism in architecture, uniting art and technology, and promoted a closer cooperation between "fine" and "applied" arts and between art and society. The institute was closed down by the National Socialists in 1933. Some of its members became highly influential teachers in the USA, where amongst others "New Bauhaus" was founded in Chicago in 1937.

Cantilever Asymmetrical structural system in which a member is rigidly fixed at one end in a supporting structure and free at the other (f. ex. balcony overhang), usually horizontal.

Cavity Wall Expression for a wall construction that consists of two slabs which are connected only by metal stays, so that there is a cavity between them.

Concrete, Reinforced Concrete (Latin: bitumen) Composite material. Additives (sand or gravel) are mixed with cement and water and poured into a cast. Reinforced concrete is used with building parts that are under high static pressure. It consists of concrete equipped with steel reinforcements.

Cornice Profiled wall decoration that serves as a partition of the building. It protrudes horizontally from the wall.

De Stijl Dutch group of artists and periodical of the same name, founded in 1917 by Piet Mondrian and Theo van Doesburg, who demanded elementary components of primary colors, flat, rectangular areas and only straight, horizontal, or vertical lines to simplify the language of forms for art and architecture.

Expansion Joint Mobile construction joint that enables individual parts of the building to contract or expand under the influence of heat or cold. Wright used this to lend a certain agility to his Imperial Hotel in Japan and prevent its collapse in the case of an earthquake.

Façade Outer appearance of a building, usually the front. It can reflect the inner structure of a building or cover it, like in historicist styles.

Floor plan Architectural design of the horizontal of a building. It shows dimensions and location of the rooms, the size and number of doors, staircases, and windows. In his early years, Wright mainly designed cruciform, T-shaped, and H-shaped floor plans. In his later years, he experimented increasingly with unusual geometrical shapes.

Foundation Foundation or basis of a building consisting of walls or pillars rooted in the soil.

Frieze A band which serves as a surround or decoration for architectural partitioning. Mostly shaped plastically or painted.

Gallery (French: roofed corridor) In architectural terminology, it describes a wide communicating passage on the outside of a building or on the inside in high rooms, especially in an atrium. It is usually open to one side.

Hermetic Describes a compact, windowless building that is completely isolated from its surroundings.

Hip Roof A roof with four sloping ends and sides.

Historicism Collective expression for different directions of style, mainly between 1820 and 1920, which took up historic building styles and forms,

for instance neo-Romanesque, neo-Baroque, neo-Gothic. Wright accused it of having too much meaningless ornamentation.

International Style Expression by Henry-Russell Hitchcock, Philip Johnson and Alfred H. Barr for their New York exhibition of modern architecture in the Museum of Modern Art in 1931. The International Style shows the function of a building from the outside. Its representatives came mostly from Europe: Walter Gropius, Ludwig Mies van der Rohe and Le Corbusier rejected historicism with its elaborate ornamentation and preferred clear, cubic forms, symmetrical arrangements, and large window fronts.

Master Plan Instructions in city or landscape planning for construction in a certain area, which determines size, volume, and location of the buildings and streets. The detailed designs for the individual buildings follow in the next step.

Monumental Originally an expression for works of art connected to a monument and therefore defined by its dimension. Nowadays, the expression is used to describe something impressively large and also hints at a representative execution of the work of art.

Neo-Romanesque Style (Greek: neos, new; Latin: romanus, roman) Architectural style in the late 19th century which takes up the basic elements of the Romanesque style (1080 to 1150) and reproduces it in free interpretation. As in Romanesque architecture, the style is characterized by round arches and surrounds and a heavy monumental solidity.

Organic, organic architecture Collective expression for various buildings and concepts since the end of the 19th century striving at the integration of the building into the landscape. The central idea is that the building should grow naturally out of the surroundings. Wright's interpretation of organic architecture developed out of his art theory, based on the American natural philosopher Ralph Waldo Emerson, and out of his inclination toward geometric abstraction.

Portfolio An illustrated book with photographs or prints.

Prototype (Greek: protos, first; typos, print) First realization of an idea or, in architecture, of a new design of a house, that serves as sample to all following buildings.

Protruding Parts of the building (wings, rooms, terraces) protrude into the surrounding landscape, thus integrating the building into the surroundings.

Saddleback roof (also Gable roof) Most common form of roof, consisting of two roof sides sloping down from a central ridge. At the front and end of the building, they create a vertical triangular surface (gable).

Spanish Colonial Style Term for the architecture in the imported Baroque style in the former Spanish colonies in Middle and South America between the 17th and 19th century. At the beginning of the 20th century, the Spanish Colonial Style influenced the American architecture, mainly in the West-Coast states.

Skylight Opening in the roof of a building which serves to provide the interior with daylight.

Static (Greek: statikos, bring to a halt) The science of the balance of natural and construction forces, which work on a body or building. Calculating the static shows the distribution of these forces according to their strength and direction.

Terracing (French: terrace, step) Artificial, horizontal treading of a landscape or building.

Vertical Plane Architectural drawing which shows the outside view or the partition of a sector of the wall on the inside.

Wing Long, often rectangular part of a building that is joined to the main building.

Index